LIFE STAGES OF WOMAN'S HEROIC JOURNEY

A Study of the Origins of the Great Goddess Archetype

Susan A. Lichtman

The Edwin Mellen Press
Lewiston/Queenston/Lampeter

Library of Congress Cataloging-in-Publication Data

Lichtman, Susan A.
　　Life stages of woman's heroic journey : a study of the origins of
the great goddess archetype / Susan A. Lichtman.
　　　　p.　cm.
　　Includes bibliographical references and index.
　　ISBN 0-7734-9699-8
　　1. Women--Psychology. 2. Archetype (Psychology) 3. Goddesses-
-Psychology. 4. Feminist psychology. 5. Self-actualization
(Psychology) I. Title.
HQ1190.L494　1991
155.6'33--dc20　　　　　　　　　　　　　　　　　　　　91-31494
　　　　　　　　　　　　　　　　　　　　　　　　　　　　CIP

A CIP catalog record for this book
is available from the British Library.

The Edwin Mellen Press　　　　　　　　　　The Edwin Mellen Press
Box 450　　　　　　　　　　　　　　　　　　　　　　　Box 67
Lewiston, New York　　　　　　　　　　　　Queenston, Ontario
USA 14092　　　　　　　　　　　　　　　　　CANADA L0S 1L0

The Edwin Mellen Press, Ltd.
Lampeter, Dyfed, Wales
UNITED KINGDOM SA48 7DY

Printed in the United States of America

To Stephen

Table of Contents

Acknowledgements

Usually, when we speak of heroes, we think of people larger than life, persons of great deeds and large doings, people who have changed the shape of the world, or at least, the way that world is perceived. But, in searching for our heroes, Alice Walker reminds us that, "We have constantly looked high, when we should have looked high — and low."[1] In this regard then, I look to my mothers and my sisters who have contributed to this undertaking by contributing to me their friendship, their support, and their love. To recognize the woman heroes in our own lives and to acknowledge their own heroic adventuring is to return to them the gratitude and appreciation for clearing the way for those of us who are following close behind.

This book would not have been accomplished without the education and enthusiasm for women's studies afforded me by Professor Barbara Lootens, of Purdue University North Central, whose interest in and contributions to this project, as well as faith in me, has never waned. She exemplifies what is best in all mentors: the ability to recognize the promise of any of her students and the gift to nurture that promise through to fruition.

Through networking on a political level, I was initially introduced to Denise Hoff who shared my passion for women's studies, women's history, and women's culture. For the past ten years, and innumerable cups of coffee, our work sessions produced some of the best papers either of us had ever written on women's literature and the traditional canon. Her support and friendship over the years cannot be overestimated. That initial political contact has provided us both with a lifelong friendship based on a shared sisterhood and a shared sense of family and caretaking.

I am also grateful to the colleagues, friends, and teachers who, over

the years, have encouraged the free play of ideas and arguments in fostering an open atmosphere for their classrooms. And who, by their example, have contributed to teaching as a noble profession: Professor Bernard Lootens, Dr. Patricia Buckler, Dr. John Pappas of Purdue University North Central, and Dr. Dolores Freese of the University of Notre Dame.

To all of my mothers and sisters, my constant pole-stars, who have helped influence and educate me about women: Lorraine Dilsaver, Dona Speer, LaDona Lichtman, Edythe Levin, Dorothy Levin, Suzanne Nadel, Lucille Saviano and Anna Menichetti: all my personal heroes. I am also grateful for the support and friendships extended to me by my community through speaking projects and conferences. A posthumous dedication must belong to Professor John J. Stanfield, of Purdue University North Central, whose encouragement and honesty will always be the legacy of his students. Finally and most of all, I wish to thank my family for their support and their sacrifices in waiting patiently for this project to come to an end: Stephen, Rachel, Sarah, and Elijah.

Notes

1. Alice Walker, "In Search of Our Mothers' Gardens," in *In Search of Our Mothers' Gardens: Womanist Prose* (San Diego: Harcourt Brace Jovanovich, 1983) 239.

Note To Readers

Barbara J. Lootens

This book should prove useful to both faculty and students who are undertaking a study of female development. By collating material from psychological, mythological, literary, and cultural sources, Ms. Lichtman has provided a panorama of the heroic epic for woman, which would be invaluable as a supplementary text in women's studies courses. For individuals who wish to enrich their own knowledge of woman as hero, this work provides a ground source of information which makes the journey both intellectual and visionary.

Purdue University North Central

Introduction

God's Mother is the Goddess herself.
Naomi Goldenberg

The purpose of this book is to provide a model of the female monomyth of heroic self actualization that validates woman's experience and celebrates her development of self as hero of her own life epic. To do so, I have chosen to deal primarily with the remnants of the oldest pre-patriarchal mythological figures and motifs that place woman at the center of her own adventure story in order to see woman as the ancient pre-patriarchal peoples must have — mystical, magical, and divine. These motifs reveal woman as more than an imitation of nature: she is creation incarnate who experiences outer and inner journeyings in constant transformations of self and energy as she passes through her life phases of virgin, mother, and crone.

I am taking the suggestion of such feminist critics as Mary Daly, Annis P. Pratt, and Helene Cixous to glean, steal, or "spin among the fields"[1] of established theory — literary, psychological, mythological, and feminist — to derive what I call the female monomyth of self actualization wherein woman as hero experiences her own quest toward individuation. The fields I have visited belong to Jung, Freud, Daly, Briffault, Chodorow, Campbell, Pratt, French, Goldenberg, Perera, Lauter and Rupprecht, as well as many others who have investigated and analyzed the human experience of growth and change through mythological motifs. I have done so to name and reclaim what is valid for woman and her experience.

Based on feminist archetypal theory and feminist cultural thought, this book links the idea of archetypal images, signs, and symbols to a

model of the hero's quest for woman which places emphasis on the interior development of her self rather than exterior social connections. I am concerned with the poverty of strong, intelligent female figures who can be seen as progressing through a lifetime of development rather than the overabundance of other figures who are arrested in one phase or age with no progression toward self fulfillment whatsoever. In relation to what Demaris S. Wehr calls woman's "increasing symbolic impoverishment,"[2] I am seeking to reaffirm and rediscover signs, symbols, and images that can enrich and empower woman's psychic and spiritual existence by reflecting woman's experience more accurately.

> Archetypal theory must understand the feminine as more than a negative or positive pole in a masculine-feminine duality. It must transcend what men have projected from within their own psyches as ultimate feminine archetypes, and it must be based on a re-evaluation of long-held beliefs and practices which characterize women as outsiders in culture.[3]

Like most feminist critics, I will not use the terms of anima and animus because of the dangers of implying limitations based upon gender. Instead, I interpret both Logos and Eros to be psychological components of both sexes. At the same time, I also reject the hetaira and the amazon believing them to be artificially projected patristic images of woman. Unlike the followers of Jung who focus on the image of mother in isolation, I prefer to reintegrate the concept of mother within the life phases of virgin, mother, and crone. By retrieving the original matristic interpretation of the experience of woman projected by the ancient archetype of the Great Goddess, I hope to restore a pattern of progression and continuity to female development.

Rather than a static image, I prefer to see this archetype as a process which moves woman closer and closer to the realization of an independent self that is linked to the collective through a balanced relationship of autonomous and communal responsibilities. I employ virgin, mother, and crone as biological markers, not to limit woman to biology but to use biology as a source and resource for understanding the

potential of woman's mind and body. As Adrienne Rich writes, "We must touch the unity and resonance of our physicality, our bond with the natural order, the corporeal ground of our intelligence."[4]

The female monomyth suggested by the archetype of the Great Goddess forms a collective of woman's experience that acknowledges universal mythological patterns of female development as a progression from virgin to mother, mother to crone, and crone back to virgin again in a cycle that imitates the seasons of the year and the phases of the moon. All cultures across the world have or had at some time a mythological motif of woman in the process of transformation. This is not to negate the differences between woman's experiences in the many cultures around the world, rather it is a method that can validate the varieties of female experiences beyond their racial, religious, or national lines;

> It remains for women to interpret the Goddess as women relating to Woman; and only black women, Oriental women, and Native American women can completely rediscover and reanimate the original Goddesses of Africa, Asia, and the Americas for us.[5]

I must emphasize that this concept of the female monomyth a woman's quest for self actualization is *a* truth, not *the* truth of interpreting the experience of woman. It is a suggestion that can enrich the dialogue of women among themselves as well as enrich the relationship of women to their societies by reaching the "buried parts of the personal life (our personal unconscious) which we hold in common with others (the collective unconscious)."[6] Not all experiences are the same, but I believe we can recognize some universal truths that can unify and empower women. With the realization that they are heroes in their own right, their quest becomes one of importance and primacy in understanding human existence and development. Individually, woman's quest for self actualization can empower growth and development while collectively augmenting that personal power to that of her sisters.

Notes

1. Annis P. Pratt, "Spinning Among the Fields: Jung, Frye, Levi-Strauss and Feminist Archetypal Theory," in *Feminist Archetypal Theory: Re-Visions of Jungian Thought,* eds. Estella Lauter and Carol Schreier Rupprecht (Knoxville: University of Tennessee Press, 1985) 93-94.

2. Demaris S. Wehr, "Religious and Social Dimensions of Jung's Concept of the Archetype: A Feminist Perspective," in *Feminist Archetypal Theory: Re-Visions of Jungian Thought,*eds. Estella Lauter and Carol Schreier Rupprecht (Knoxville: University of Tennessee Press, 1985) 44.

3. Pratt 130.

4. Adrienne Rich, *Of Woman Born: Motherhood as Experience and Institution* (New York: W. W. Norton, 1977) 21.

5. Monica Sjöö and Barbara Mor, *The Great Cosmic Mother: Rediscovering the Religion of the Earth* (San Francisco: Harper & Row, 1987) 31.

6. Rachel du Plessis, The Critique of Consciousness and Myth in Levertov, Rich, and Rukeyser," in *Shakespeare's Sisters: Feminist Essays on Women Poets,* eds. Sandra M. Gilbert and Susan Gubar (Bloomington: Indiana University Press, 1979) 289.

The Hero's Journey

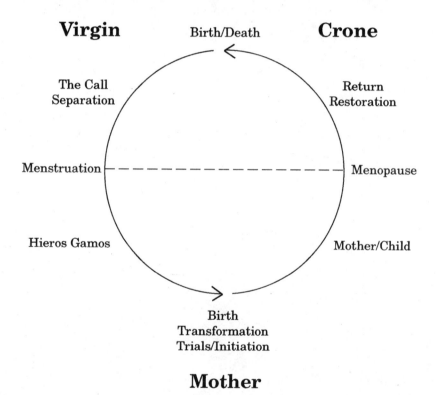

I. Prologue:

Definitions of the Feminine

Women. Invisible as humans.
Helene Cixous

Because for centuries, women have been defined by men, the signs, symbols, and images of women in literature and myth reflect the perceptions of a patriarchal social system built on submission, obedience, and self-doubt. In accepting patriarchal definitions of the feminine, women limit and confine themselves, and their lives, to the perimeters of those definitions. What we read, what we see, even the stories we tell our children are psychologically loaded with those confining and limiting definitions of the feminine. From our first experiences with fairy tales, we wonder why the princess always has to be saved by the prince, why witches are always female, why "happily ever after" has to be enough.

Living at odds with the established male order creates for women a sense of self-doubt that is compounded by the fear or the recognition of the lack of a personal correspondence between the exterior world and the interior reality of what it means to be a woman. Because these fears do not constitute as much a desire for reprisal as uncertainty about the self, the resulting lack of integrity between the outward signs and the interior self leads women to live on two levels simultaneously and ultimately culminates in the destruction of the female self.

Women know that the female experience is more than biology. With their increasing participation in all aspects of public and private life, they have found that the constrictions of the past do not serve to define them but to define only their bodies. The restriction of the female experience to

the physical relegates the body to the dubious distinction of object; woman herself is no longer the subject; only her body is of interest. In becoming objectified, woman is lost. To save herself, she must resist the socially conditioned response engendered in patristic philosophy and legitimized by patristic control by regaining the power to define herself within the scope of her own experience.

In redefining female signs, woman can create for herself a sense of purpose for her own life. She, too, like the heroes of past ages, can actualize her own journey of self discovery. Like those heroes, she too can embark on the marvelous adventure of life where growth and change can become dynamic tools of the psyche. The place of the hero, in myth and in literature, is a place of the self; by redefining the female, the hero's adventure can become a place for woman wherein the female psyche can explore the dimensions of her own truly unique human experience.

Because woman has been excluded from the androcentric world view of the male, his has always been the journey of importance, of development, of change. She, as female, is automatically excluded from this center of change, relegated instead to the circumference of the circle. Traditionally, male oriented definitions of the female correspond to the commodification of the female as object or as property of the centered male: virginal, intended, engaged, pregnant, menopausal; what stage woman is in biologically determines what definition is applied. But by placing woman into the center of importance, with an emphasis on her psychological development, we can begin to define her journey of self acceptance in terms other than the biological. By redefining the traditional literary and mythological symbols and images of woman, we can begin to understand not only our present but our own past as well. More importantly, we can also begin to build a future.

It seems only natural for feminist scholarship to search for a time or an age when woman was not defined or commodified by men. To conceive of a time when woman was a powerful, mystical being whose very presence filled the air with awe and wonder is to recreate a world in which female fulfillment stretches far beyond the physical into the metaphysical realm. The stars, the sun, the moon, the very earth of sustenance would

be defined as female, gyno-centric. It would be a world in which the very name of woman would imply the divine. By associating the female with the transcendant, woman would be released from the sense of subordination inherent with a distinctly male Father God. With the recognition of the existence of an ancient Great Goddess, woman could become her own center of the universe, not simply as a biological creature, but as a human creature whose talents and imagination can extend beyond the temporal.

But we must remember that this center implies the whole of experience. And because woman has traditionally been separated from that whole, to rediscover her own experience, she must return to the ancient myths and stories that have their basis in prehistorical societies centered around women. Inanna, Lilith, Demeter and Persephone, the characters born of these myths have achieved the status of archetypal figures in their representation of the female principle of creation. In these myths, as with others, the female experience has its source within the center of the universe, and the myths that surround that experience correspond to the interior life of woman.

For woman to have a future in modern society, she must first have a past that contains her own traditions, her own folklore, and her own heroes. With a sense of shared female culture, she can use the signs, symbols, and images of woman that have existed for centuries to move with a greater sense of confidence and purpose while changing traditional attitudes toward every field of scholarship. From religion to science and from literature to psychology, the lost voices and experiences of millions of women throughout the ages can guide her to her own personal development. Female images and signs were never fully expressed under the male domination of the literary and scientific worlds. Now they have begun to emerge as important symbols in the writings of women where they can become personal expressions that reunite woman with her world.

No one woman ever stands in the same place throughout her life; there is always change, development, and self actualization. And female myths constitute her interior life. In contrast, traditional interpretation, because it is based on an androcentric world, presents only fragmented female images submerged in a network of male imposed archetypes,

creating a mythological system that supports the patriarchal social organization. When a particularly female point of view is adopted, however, it becomes obvious that female archetypal characters were born of a time that predated patriarchy, a time in which the figure of woman moved from child to actualized adult in a natural evolution of change and development.

From the earliest portrayals in prehistory to the latest twentieth century depictions, all female images have had more to tell than the obvious. It is not enough to be familiar with their literary and mythological names. At one time, the image of the female constituted a whole and complete vision of woman, who used her power of creation on a journey of self actualization:

> That journey is the goal of the initiation mysteries and of work on the astral plane of magic, even as it is the goal of therapeutic regression... The need for this journey fuels the current interest in the psychology of creativity and the early, pre-oedipal stages of human development and their patholo-gies.[1]

The journey, designed for the individual but told in archetypal terminology, is the psychological Grand Tour every woman must embark upon, if she is to become true to herself. Symbolically, then, the archetypal journey records the separation from parental identification, the develop-ment of the individual psyche, and the eventual coming to terms with the individual's present in relation to the past and the future. I use the term self actualization in this regard: the development of the individual psyche to its fullest potential, an actualization of the self and all of its possibilities that would enable the individual to become more fully aware of herself as individual and as part of a greater whole.

Feminist scholars have been wrestling with Jungian theory, at-tempting to define a process of psychic development that can be called uniquely woman's. Although no unified design is agreed upon yet, most scholars can find adequate psychological footing in the use of Jung's term "archetypal." Naomi Goldenberg writes:

> "Archetypal" might be usefully employed as an adjective to describe the degree to which an image affects us. Each

fantasy, dream, or life story could be classified by the impact it carries for our lives, our communities and the times of our history. We could begin to understand that what binds us together as human beings is not, in fact, the contents of our religious and psychic imagery but rather the continual process of producing and reflecting on imagery... we could build communities around the observing and sharing of the imaginal process alive in all of us.[2]

In other words, the process takes precedence over the individual image. Without the process of growth and change for the individual, the image becomes an arrested, stagnant moment as opposed to a dynamic continuum. Beginning in the nineteenth century with the work of the Swiss scholar Johann Jakob Bachofen and continuing with Robert Briffault, Sir James Frazier, and Jane Ellen Harrison, among others, examinations of prehistorical and ancient cultures have significantly tempered traditional notions about the role of woman in society. Today, women's analyzing of women's experiences has radically altered traditional views of the female life. As more women enter the traditional fields of scholarship, more information is reassessed and redefined to provide a more personal, a more accurate analysis of what it means to be female:

> The concept of the archetype could be, in the hands of feminists, a way of recovering and revaluing women's experiences, of discovering nodal points in women's history.[3]

To look at the development and use of archetypal images in myth and literature is to see the process of social history and social conditioning take place. With a Jungian base and a cultural feminist point of view, it becomes possible to link individual female archetypal images into a multidimensional, moving portrayal of female experiences.

With all this information, and all these areas of history to explore, where do we begin to change our own traditional interpretations? One of the most challenging endeavors for feminist scholars is to redefine female archetypal images to correspond to the female experience in order to invalidate those defined and codified by patriarchal interpretation. I suggest that these redefined images from myth and literature can be linked together to indicate a developmental pattern inherent to the

evolution of a female psyche. I also suggest that a beginning be made by returning to the only original archetype in existence before the patriarchal epoch: the Great Goddess; for within that concept are the major developmental roles of woman's experience: the virgin, the mother, and the crone. I propose these terms be expanded to include the female understanding of the psychological functions that go beyond their biological implications. For example, although virgin, in the patristic sense, indicates a young woman of marriageable age (hence, a commodity of exchange), the redefined sense of the word should stress the power of personal choice or decision, the freedom to determine one's own life. Motherhood, traditionally seen as a nurturing or life-giving role biologically, can just as equally imply the personal acceptance of responsibility, the choice to nurture or create, the acceptance of a leadership role within the family or community. Being a mother is not simply a biological occurrence, as any woman who has chosen to adopt a child can tell you; metaphorically, motherhood extends well beyond its biological limitations. Crone, the last and final phase of the Goddess, must be redefined as well to include the power of wisdom, experience, and memory, the keeper of social history and guide to the young.

By redefining and expanding these archetypal images, we can begin to correlate a journey of self actualization for the individual female that allows for growth and acceptance beyond the biological limitations; a journey that allows a hero's adventure, but in a female context with an emphasis on female life experience.

No matter where or when the hidden threads of women's history are found, many scholars have discovered that they lead back, however dimly, to the darkened, preconscious prehistories of humankind. And although the evidence found is subject to various, and in some cases, conflicting interpretations, many scholars agree, on the basis of surviving artifacts and systems of mythology, that patriarchy was not a beginning but a reaction against another kind of social organization that predates patriarchy by thousands of years. Through the work of archaeologists and anthropologists, we now have a name for that kind of social organization: matri-focused culture.

Prehistorical Origins

By definition, matri-focal, matrilineal or matri-centric culture denoted a society in which the mother-child unit formed the basis of the social group:

> The structure of matricentry was loose: families clustered around a mother or set of mothers (sisters), who had strong bonds with their children, especially with daughters, who probably remained with the mother throughout her life [sic]. Men were marginal in the matriliny; the closest bond for men was with their mates and the children of their sisters.[4]

Scholars such as Joseph Campbell, Merlin Stone, Riane Eisler, and Marija Gimbutas suggest that these societies were unique in that women were not subordinate to men but simply enjoyed the responsibility of, and the fear and the awe associated with, the biological function of procreation and nurturance. Females and small children were the permanent residents of these early social groups. Adult males were transients — wandering about the centered groups in hunting bands or in solitude or isolation. Adult females were perceived as holy, sacred beings who could create life spontaneously — or so it seemed before the correlation of paternity was established. Blood was seen as the miracle essence of life. Nothing could live without it. And women, who bled for seven days a lunar cycle without dying, were seen as the unique embodiment of that miracle essence. Through that same blood, they gave birth. In many ways, it was inexplicable, and the inexplicable carries its own burdens of fear. There are many indications that primitive men, to this day in fact, tried to emulate the adult female with bloody adolescent rites of their own for young men being initiated into the company of men, creating a sort of second birth for these new men.[5] That women were endowed with the privilege of creating life was enough to create some serious questioning as

to why men could not: "The ego formation of the individual male, which must have taken place within the context of fear, awe, and possibly dread of the female, must have led men to create social institutions to bolster their egos, strengthen their self-confidence, and validate their sense of self-worth."[6] Frustration in search for understanding quite often produces resentment.

Because women's menstrual cycles were linked to the phases of the moon, because they were the givers of life, because from their bodies flowed the very milk of life, nature and women were seen as intrinsically linked to the survival and sustenance of the group. As the matriarch of a particular group grew old and died, she became revered as the original source of life for that social group. Religious rites and rituals were closely associated with her life and the phases and seasons of nature. As a result of this connection, the first godhead conceived by these female-oriented people was that of a Goddess. She eventually became the very earth that sustained the people and from whom the plants and animals gained their sustenance as well. This initial phase of mythology is presented by Joseph Campbell in *The Masks of God: Occidental Mythology* as the most ancient: the period of time wherein the female deity created alone and from her own body.[7] Today, she is referred to by the same name she had then: Mother Nature.

And, as God is known by many and varied names: Father, Adonai, Tao, Deus, Allah: we understand that all the names refer to the same God. In the same way, Inanna, Isis, Maat, Astarte, Sophia, Magna Mater all refer to the same Goddess. This Great Goddess eventually incorporated the three main phases of a woman's life: virgin, mother, crone, as well as the first concept of trinity in a single godhead. Although all three represent quite separate and distinct personages, all three together represent the span of time and change inherent in every individual woman's life. Each phase took on a personality of its own, but each represented the single individual female on the quest toward self actualization, a quest that emphasized the female's relationship to herself rather than her relationship to any one male. While her biology was never denied in any of these three stages, it was her psychological evolution in

relation to her biological status which provided her with the power and stature of hero.

Although Jung defined several female archetypes, including the hetaira and the amazon, I prefer to use what are perceived to be the original aspects of the primal Great Goddess as a basis for redefining and reclassifying the major female archetypes. Virgin, mother, crone more naturally correspond to the observable passages of each female into full actualization. These three phases conform quite realistically to the progression of a woman's life as originally perceived by ancient matrilineal peoples. The inclusion of such patristic terms as hetaira and amazon already suggest the presence of a patristic social organization and are, therefore, prejudicial to any feminist understanding of woman as divine form.

She herself was the universe, the sky, the stars, the earth, the tangible environment that cradled or destroyed the life held within her. She herself represented the original concept of the virgin birth because she alone created from her own body. She also represented death, and into her womb, her earth, her dead children were replaced with the hope and expectation of rebirth. Rituals and rites imitated her life-giving and life-taking properties. Hence, sacrifice developed as an integral part of these rituals, paralleling that which was seen in nature: namely, from death comes life, and from life comes death. Woman, however, was beyond death; she was linked inexorably with the continuing, regenerative processes around her; she reproduced herself in the guise of her daughters, and, perhaps more intimidating, she reproduced sons as well. Man, who could not reproduce himself as woman could, was seen as peripheral to human life.

The concept of rebirth was a basic tenet for these people; as the earth never really died, neither did her children. For the early hunting groups (forerunners of the pastoral societies), the animals killed were treated as deities themselves; appeasement rites to these animal deities developed in order to assure the animal's return to the group. In the early foraging and gathering societies (forerunners to the agricultural societies), rituals developed to insure the new vegetative growth for the spring.

As these rituals were carried out by the high priestesses of the social group, stories were probably told to explain the meaning and purpose of the various rites to the whole community. These stories (which have become our myths) involved the Goddess and her powers of creation, death, and rebirth. One of the oldest surviving myths of this kind is the story of Inanna and her descent into the underworld.

Fragments of Myth

Myth is the history of its authors, not of its subjects;
it records the lives not of superhuman heroes,
but of poetic nations.
E.B. Taylor

This Sumerian myth, whose only surviving copy is recorded on clay tablets from the third millennium b.c.e.,[8] tells the story of Inanna, the Sumerian Goddess of heaven and earth, and her adventures in attaining her own sense of womanhood and divinity. The story's beautiful ancient poetry, as skillfully recreated by Diane Wolkstein in her book *Inanna: Queen of Heaven and Earth*, is one of the few fragments remaining that recounts the passage of Inanna through the phases of virgin to mother to crone, exemplifying the self actualization of Inanna into full and complete womanhood. Although the phases are marked biologically, the text places an emphasis on the psychological growth and acceptance of self that Inanna attains as she moves through her adventures as an active participant rather than passive victim of the forces that surround her. Beginning with the Sumerian account of creation, the text then records Inanna's celebration and acceptance of her vulva, her young womanhood, and the potential of life that she embodies. She meets with Enki, the god of wisdom, who provides her with the accoutrements of leadership and civilization for her people which she actively accepts and chooses to take

on. Next, her courtship with the shepherd Dumuzi is recounted in a joyous celebration of human sexuality. And although Inanna gives birth to children, it is her descent into the underworld to confront her sister Ereshkigal which provides the very powerful account of the descent of woman into herself in order to arise empowered from the maternal experience. When Inanna returns to her own world and condemns Dumuzi to the death that she herself has survived, Inanna then moves into her most powerful and terrifying aspect of harbinger of death.

There are few remnants of myth that identify the heroic journey of woman through the major phases of her life. But Inanna's story, along with those of Demeter and Persephone, Lilith, Nokomis and Onatah, Anieros and Axiocersa, give some indication that at one time, woman was the hero of her own life epic. Her life was representative of the natural world that surrounded her. She was identified as nature, as the land, but her influence extended far beyond the natural world to the development of culture, art, agriculture, religion, and social organization: all of which can now be traced back to woman's development before the discovery of paternity.

When pastoral and agricultural societies began to develop, the responsibility for the survival of the group became more evenly split between men and women. Women were chiefly cultivators and child-bearers, while men supported the group through means of protection, hunting, or herding domesticated livestock. No one knows for sure how the discovery of paternity came about, but we can assume that observation of natural processes among animals influenced the discovery. When people observed the same flock or herd day after day, season after season, and, for the first time, scrutinized the corollary between animals mating and the subsequent birth of new animals, they realized that males were necessary to the procreative process. The stories and myths of this time reflect the newly discovered paternity. No longer did the Goddess create in solitude; now, her son or lover created with her, as in the stories of Inanna and Dumuzi or Isis and Osiris of Egypt. Partnerships flourished in the heavens as equalitarian parenthood developed on earth. This parallels the second stage of mythology identified by Campbell wherein

the Mother Goddess creates the world with her son or consort. But the traumatic discovery of paternity, in the psychological sense, gave the male the opportunity to reevaluate his own position in the universal scheme of things. Paternity allowed the male to assume superiority over woman through property and control; her children now became his children; she, in turn, became his possession.

The advent of paternity brought with it the advent of private property. Whereas the matri-focal culture held everything, including children and food supplies in common ownership, paternity allowed ownership by the individual male to develop; nuclear families could now be identified, and "the simple shift to patrilineal descent, which permitted a man to leave his property to his children, amounted to... the degradation of women."[9] The children that once ensured the survival of the group now insured the ownership of land or livestock in a particular line of descent heretofore never reckoned: the line of the father. Common sex partners gave way to monogamous relationships, at least for the female. Her fidelity to her husband, brother, or father was now enforced by isolation from other men and separation from the other women of her birth family. Her mystical life-giving body was now demoted to mere vessel for the seed of man, a view that is much later expressed in the most dangerous rationalization for matricide, Aeschylus' *Eumenides* when Apollo exclaims:

> The bearer of the so-called offspring is not the mother of it,
> but only the nurse of the newly-conceived fetus. It is the male
> who is the author of its being.[10]

The myths of this ruinous time period are marked by violence and destruction between the male and female deities or forces. Inanna's stories and myths involving Dumuzi reflect the initial pull between coupling and self-possession. But where two lovers once created out of joy, they now create out of opposition. The male consort, now elevated to the position of deity by his own powers of paternity, destroys the Goddess and, from her body, creates the universe, as in the Babylonian myth of Tiamat and her son/consort Marduk who violently divides his mother's body to form the upper and lower waters of the universe[11] or as in the myth of

Cipactli of ancient Mexico, whose body was torn apart by two serpents for the same purpose.[12] This stage of mythology corresponds to Campbell's third developmental phase wherein the son/consort creates from the destroyed body of the Mother Goddess; Gimbutas places this phase somewhere between 4300 b.c.e. and 2800 b.c.e.,[13] although specific time periods are arguable at best. The Goddess no longer creates from her own desire but from the violence and destruction of the male who originally emerged from her body. He now controls, through the power of paternity, when and how the Mother Goddess will give birth to the universe. The decision is no longer her own. Everything female, once associated with magic and mysticism, is now demoted to evil and witchcraft. Woman's spiritual nature ceased to exist as she became increasingly associated with only a physical (hence, lower) animal nature. Man, who was always the "other", separate from nature, now rose to new spiritual heights separate and superior to nature. And so, the development of patriarchy moved to its ultimate antithesis: the creation of an all-powerful Father God who creates, not from nature or out of nature but "ex nihil", out of nothing. This is the final stage of the development of mythology according to Campbell: the creation of the universe by a single male god.

This monotheistic strand not only survived but greatly influenced the cultures around it. The creation and resurrection myths that once told the story of human beginnings in relationship to nature became histories of the birth of patristic culture and patriarchal civilization. Oral tradition, once used exclusively as a means of transmitting that history through succeeding generations, gave way to the relatively new art of writing and priestly scribes. The priest-legislators of that history were hard pressed to legitimize some of the ancient myths still held fast by the common people; this would become a constant problem right through to the Middle Ages. These myths were finally legalized through patristic interpretations and analogies that allowed legitimacy to patriarchy and the new social organization of its society.

As an example of how these myths were changed, and consequently society's perceptions of women, Genesis' first two chapters can be used to demonstrate the change in attitude toward women and their procreative

functions. By the time the Bible was written down and canonized, many of the myths and stories incorporated were intertwined through various authors and sources. These stories became the subjects of great rabbinical interpretations known as the Midrash. When the Midrash encountered the two separate creation myths in Genesis, something remarkable was recorded.

In Genesis' account of creation, there are two descriptions of the creation of man and woman. The first description tells of man and woman being created together:

> And God created man in his own image... male and female created he them. And God blessed them (Gen. 1:27-28).

The second account states:

> And the rib, which the Lord God had taken from the man, made he a woman, and brought her unto the man (Gen. 2:22).

In the book, *The Alphabet of Ben Sira*, a Midrash of the Geonic period, the two accounts were explained in terms of the legend of Lilith. Midrashic interpretation explained that the first time God made woman, he made her man's equal; the man's name was Adam, the woman's name was Lilith.[14] In the myth, Adam and Lilith, living quite peacefully in the Garden of Eden, began to argue over the manner of sexual intercourse each preferred to engage in. Quite a fight ensued. Lilith, refusing to compromise her sense of equality, pronounced God's ineffable name, which gave her god-like powers, and flew off into the night air to set up her own housekeeping on the shores of the Red Sea. Upon Adam's request, God sent three angels after Lilith in hopes of convincing her to return to Adam. But Lilith, enjoying her powers and independence, steadfastly refused to return to Eden. Instead, she transformed herself into a demon with long, wildly tangled hair and swore revenge upon all humankind. Totally exasperated with this rebellion, God then created Eve from Adam's side so Eve would always be submissive to her husband who gave birth to her.

Lilith's ancestry is very typical of what happened to the once

supreme Goddess. This once sole creator of life was simply assigned demon-duty by the new priests who gradually took over from the existing religious establishment of high priestesses. The Goddess' life-giving properties were now assumed by the new Father God, and she was left only with her destructive or death aspect. Lilith wasn't the only figure to undergo the transformation; from the Kali-Ma in India to Hera in Greece to Inanna in Sumeria, the Goddess became a nagging, negative influence upon human lives, constantly reminding man of the limits of his mortality. Without the Goddess's intrinsic connection to nature and human transience, death would be non-existent; through the Father God, however, life (at least, spiritual life) could become everlasting. In this final phase of developmental mythology, birth becomes a male function. Father God, Ra, Shiva, Kun, and Zeus all assumed the procreative function "since birth-giving was the only true mark of divinity in primitive belief."[15] This "symbolic motherhood"[16] reduced the importance of the female in relation to the birthing process and, subsequently, diminished the power and control of the Goddess over natural creation.

The figure of Lilith survived well into the Middle Ages, and even today, some ethnic cultures still protect themselves from the "evil eye", a remnant of the once powerful Lilith. Through the centuries, she has been called the Queen of Sheba, Helen of Troy, and the Frau Venus of Germanic mythology; she has appeared in other mythologies as Lamia (Greek), Kishimogin (Japanese), Baba Yaga (Russian), and Lamasthu (Sumerian).[17] In other words, any destructive female of myth can be called Lilith. Her story, and the stories of women like her, implanted the necessary fears of abandonment and isolation which kept women within their prescribed social boundaries. Lilith's quarrel with Adam set the tone for future relationships between the genders: the war between the sexes.

The search for the origins of female archetypal figures leads back to the prehistoric epoch of matri-focused cultures. The advent of the patriarchal social systems, however, dramatically and radically changed these original perceptions, as seen with the story of Lilith, and altered the nature and use of the female archetypal images, both within literature and within shared cultural myths. As opposite values existed in prehis-

tory as necessary and good for balance and harmony within nature (yin/ yang, night/day, dark/light, for example), patristic thinking divided these values into a stark dichotomy of good versus evil, with evil losing any properties of usefulness or balance. The loss of this balance entails the loss of the female principle as it was originally defined and denies women the reintegration necessary for an equilateral existence. Thus, as the Goddess was both the giver and the taker of life in matriarchal philosophy, Lilith became only the taker of life, with no redeeming qualities.

The Journey of Self Actualization

We think back through our mothers if we are women.
Virginia Woolf

As the archaic state continued to narrowly constrict women's roles in early patriarchal societies to that of commodified reproducer and care-taker, so too did women's roles in myth become restricted until women were defined only in regards to their sexuality. Gerda Lerner writes, "It is not women who are reified and commodified, it is women's sexuality and reproductive capacity which is so treated."[18] The three stages of a woman's life which once defined her personal power and control now came to define a particular phase of sexuality and reproduction. Once, the three stages of virgin, mother, crone represented the complete journey of self actual-ization the female underwent in order to achieve wholeness and purpose of life. But within patristic thinking, these stages served only to limit and constrict woman's life in relation to her connections with man. By separating the three stages from the journey of self actualization, woman was left with only the labels that defined her biological functions. Only by reintegrating the three stages as a sequential progression of development inherent within the journey, can woman partake of a developmental process that moves from the self to the communal, from the interior reality

to the exterior sign.

The journey begins, as we have seen with Inanna, with an acceptance of the female body and the empowerment of choice. Like Inanna, she continues on her way, descending into another world quite different and distinct from the world which she is used to. She suffers the humiliations and tests of courage and strength until she finally arrives at the purpose of her journey: the confrontation with another female of great power who challenges the heroine: "Women characters at the core of their quest often encounter a powerful integrative mother figure who offers regeneration."[19] Symbolically or actually, the hero dies and is reborn into a new, stronger self image. She then returns to her own world and is reunited with her own feminine inheritance, sometimes represented by her own mother, grandmother, or a past celebratory of female power and human mortality. Reintegration with the hero's own feminine inheritance occurs as an acceptance of female values and provides "a fusion... which empowers even as it exiles her from the social community."[20] Apart from Inanna's story, the myth of Demeter and Persephone also indicates the unique feminine journey of self actualization, a story whose origins are far older than the Greek culture which codified the myth in the form we read today.

Demeter, the corn Goddess, and her daughter Persephone's story is familiar to any reader of Greek mythology. Demeter's origins initially connect her to the primal image of the Great Goddess and her powers over the fruits of the earth. This connection is an ancient one, probably reflecting the fact that primitive women controlled the food supplies, constantly foraging and gathering that which was needed for the group's sustenance and eventually leading the way to early agriculture in seeding the earth. In brief, the story tells of a loving mother and daughter separated through violence and rape by Hades, king of the Grecian underworld. Persephone is abducted by Hades and dragged down to his underworld realm, leaving Demeter to rail against the powers of Olympus who offer no help in locating her missing daughter. Angered by Olympus' indifference, Demeter allows a cold and desolate winter to fall upon the earth until her daughter can be restored. The frustrated Zeus finally sends Hermes the messenger to ask Hades for Persephone's release on the

basis that she hasn't yet tasted food from his realm. Unfortunately, Persephone has already eaten several seeds from a pomegranate. A compromise is reached, however, and Persephone is allowed to spend nine months with her mother on earth and three months in the underworld of Hades' realm.

Although there are considerable differences between this tale and Inanna's, both stories indicate an initial separation from the maternal source of life, a descent into a realm of darkness or "other", and a return or a rebirth fortified with an integration of power from below with the powers of above. The conquest over death that Inanna wins is paralleled in this myth by Persephone's conquest over the darkness of the underworld. Because Demeter and Persephone are, at first, connected only with the world of nature, Persephone's abduction indicates a separation from that maternal nature into a different, darker realm. Their reintegration indicates a "remembering or a putting back together of the mother-daughter body";[21] neither is the same; both mother and daughter are significantly changed by their experience, but both are reintegrated as a matrilineal unit.

The story of Demeter and Persephone is linked to the Demeter Thesmophoric festival, a three day agricultural fertility festival held every autumn which eventually gave rise to the Eleusinian Mysteries, "the most widely influential of all Greek rituals."[22] The Demeter Thesmophoros (meaning "Demeter-Who-Established-the-Customs"[23]) celebrated the "*Kathodos* and *Anados* (Downgoing and Uprising), the *Nestia* (Fasting), and the *Kalligeneia* (Fair-Born or Fair-Birth)."[24] This festival corresponds to the hero's rites of passage which consist of separation, transformation or initiation, and return, indicating that the heroic journey of woman did exist at one time and was recognized as an integral part of woman's self development. The three day festival of the Thesmophoria mimics the waxing, full, and waning moon phases as well as mimicking vegetative growth which descends into the ground, grows up to fruition, and then returns into the ground leaving a potential seed behind it. Both the moon and the seed are important symbols for woman that have been used in just about every culture around the world to indicate this complex

being of creation and sustenance. The virgin begins, the mother creates, the crone sustains; no one portrait is adequate; all must be linked together.

The journey of self actualization serves to link these individual portraits of virgin, mother, crone into a full vision of woman; in contrast, separating the images from their inherent journey prevents the female characters from a reintegration with a female past. By redefining each phase of female development from the biological function to the psychological evolution, we can define the journey of womanhood from dependent child to independent woman, from single dimension to multi-faceted.

Notes

1. Sylvia Brinton Perera, "The Descent of Inanna: Myth and Therapy," in *Feminist Archetypal Theory: Interdisciplinary Re-Visions of Jungian Thought,* eds. Estella Lauter and Carol Schreier Rupprecht (Knoxville: University of Tennessee Press, 1985) 142.

2. Naomi Goldenberg, *Changing of the Gods* (Boston: Beacon Press, 1979) 64.

3. Estella Lauter, "Visual Images by Women: A Test Case for the Theory of Archetypes," in *Feminist Archetypal Theory: Interdisciplinary Re-Visions of Jungian Thought,* eds. Estella Lauter and Carol Schreier Rupprecht (Knoxville: University of Tennessee Press, 1985) 81.

4. Marilyn French, *Beyond Power: On Women, Men, and Morals* (New York: Summit Books, 1985) 67. See also Robert Briffault, *The Mothers*, abridged and with an introduction by Gordon Rattray Taylor (New York: Atheneum, 1977) 53, 64-75.

5. Janice Delaney, Mary Jane Lupton and Emily Toth, *The Curse: A Cultural History of Menstruation* (Urbana: University of Illinois Press, 1988) 34.

6. Gerda Lerner, *The Creation of Patriarchy* (New York: Oxford University Press, 1986) 45.

7. Joseph Campbell, *The Masks of God: Occidental Mythology* (New York: Penguin Books, 1964) 86.

8. Samuel Noah Kramer, "Sumerian History, Culture, and Literature," in *Inanna: Queen of Heaven and Earth*, by Diana Wolkstein and Samuel Noah Kramer (New York: Harper & Row, 1983) 127.

9. French 66.

10. Aeschylus, "Eumenides," in *Greek Drama,* ed. Moses Hadas (New York: Bantam, 1965) 71.

11. Barbara G. Walker, *The Women's Encyclopedia of Myths and Secrets* (New York: Harper & Row, 1983) 998-99.

12. Patricia Monaghan, *The Book of Goddesses and Heroines* (St. Paul: Llewellyn Press, 1990) 79.

13. Marija Gimbutas, *The Language of the Goddess* (San Francisco: Harper & Row, 1989) xx.

14. Joshua Trachtenberg, *Jewish Magic and Superstitions* (New York: Atheneum, 1970) 37.

15. Walker 106.

16. Walker 107.

17. Monaghan 201-02.

18. Lerner 213.

19. Annis V. Pratt, "Spinning Among the Fields: Jung, Frye, Levi-Strauss and Feminist Archetypal Theory," in *Feminist Archetypal Theory: Interdisciplinary Re-Visions of Jungian Thought*, eds. Estella Lauter and Carol Schreier Rupprecht (Knoxville: University of Tennessee Press, 1985) 105.

20. Pratt 106.

21. Nor Hall, *The Moon and the Virgin* (New York: Harper & Row, 1980) 68.

22. Charlene Spretnak, "The Myth of Demeter and Persephone," in *Weaving the Visions: New Patterns in Feminist Spirituality* eds. Judith Plaskow and Carol P. Christ (San Francisco: Harper & Row, 1989) 72.

23. Walker 994.

24. Spretnak 72.

II. The Virgin's Descent:

The Original Virgin Birth

Biology is not destiny, but like the sea, it is a beginning.
Monica Sjöö and Barbara Mor

To see the virgin state as a state of initiation into the mysteries of the female body is a definition more worthy and more relevant to women than one based on property or marital rights, or upon the integrity of the hymen. To see the individual as belonging to herself and the rhythms of her own body can enable women to embark upon the mystical journey of self actualization that begins in adolescence and progresses through adulthood toward psychological and spiritual wholeness for the individual.

But, to be able to formulate a working definition for the present, we must again return to the patriarchal past and its tradition of interpreting the concept of virgin to mean a young girl with no sexual experience, a commodity to be protected for her bride price, bought, sold, or traded by father, brother, uncle, or owner with elaborate rules and regulations concerning the preservation of her chastity developed in every patriarchal society around the world. As Merlin Stone writes, "We cannot avoid observing the continual emphasis upon female sexuality as acceptable only when women were safely designated as the property of one specific male."[1] The Levite laws of the Bible are typical of the kind of patriarchal conscriptions against woman's freedom which prescribed death for women who gave up their virginity before marriage.[2] Virginity itself was, and still is, equated with the integrity of the hymen; to lose or to give up one's

virginity essentially means to lose or give up an intact hymen membrane. Woman's virgin state is thus reduced to the condition of her reproductive organs.

Let us, then, take the patristic definition of *virgin* imposed on her from without and reassess the process of virginity from within the individual woman. Let us assume that the virgin state begins at the onset of the menses as the initial state of biological, psychological, mythological womanhood, the state in which, for the first and the last time in her life, woman is truly "one-in-herself." Let us re-member the female body and its natural phases unencumbered by societal conscriptions of daughter or wife. We begin with biology as Naomi Goldenberg writes, "All of our notions, all of our images, all of our fantasies, and all of our ideals have their sources in our bodies. Our mental and physical lives are of one piece — just as a plant is continuous with both its foliage and its roots."[3] So we must begin this journey of self actualization from within the female body, the place of initial descent, by understanding that the original intent and ancient definition of the word *virgin* was to indicate a young woman who is "one-in-herself," meaning one without the exterior ties or responsibilities to the social group, a "young woman who accepts rather than fears her connection with nature,"[4] but whose personal integrity, rather than her hymen, remains whole, intact.

Joseph Campbell writes that the beginning of the hero's adventure involves a descent into unknown or unfamiliar surroundings. The hero descends in response to a call that beckons him from his safe world of daylight into a night world of mystery and danger.[5] So too does the beginning of a woman's journey toward self actualization commence with a descent initiated by a call to transverse worlds and begin her own heroic adventure. This call for woman is the onset of menses. For many primitive tribes, this onset means seclusion or isolation of the young woman from general society:

> In most native cultures the world over, the first period is accompanied by rites which give formal notice to the menarcheal child that woman's place in society is indeed a special one. The most widespread practice is the seclusion of the

menstruating girl from the tribe for periods lasting from a few days to a few years. During this seclusion, the girl is taboo. She may be prohibited from seeing the sun or touching the ground; she may not feed herself, handle food, or eat certain foods considered dangerous to her in this state. The circle of bushes or whatever barrier is placed between her and her people will probably also serve as her isolation hut during later periods.[6]

This isolation can be interpreted in two ways: first, that the isolation serves to protect the rest of the tribe from the pollution and/or danger of the menses; or, second, that the isolation gives the young woman the opportunity to meditate on the mystical changes taking place within her body, giving her the occasion to gather strength from this first initiatory phase of adult womanhood. Rather than the first definition which presents the patriarchal view of the menses as dangerous or polluting to the rest of society, it is the second interpretation that I wish to emphasize because it views the onset of menses as holy and sacred in relation to the individual woman; to bring the definition of woman back within the woman herself and out of society's artificial conscriptions is what brings purpose and meaning to this phase of individual development.

At the onset of the menses, the female crosses over from the world of childhood into the world of maturity. As in the festival of the Thesmophoria, the initiate begins her holy ritual with a descent, a down-going, into an underground chasm or cave which is "considered analogous"[7] to a woman's womb. As the bleeding begins, her attention is drawn downward into that dark region hitherto ignored or taken for granted. Now, the womb calls out for recognition; now, the descent of the hero can begin. From the region of the common day of childhood and innocence to the dark depths of this mysterious adventure of change and uncertainty, the hero must attune herself to sensations and feelings never before experienced. She separates from her own connectors of childhood in order to become fully conscious of the changes that will affect the rest of her life. In analyzing female symbols and deities from the prehistoric past, Marija Gimbutas recognizes the signs used by ancient artisans conveying the

virginal aspect of the Great Goddess which revolve around

> rebirth, renewal, and transcendence [and] is accompanied
> by the symbols of "becoming": eggs, uteri, phalluses, whirls,
> crescents, and horns that resemble cornucopias...[as well
> as]... the form of a bee, butterfly, or caterpillar.[8]

She is the waxing moon, spring incarnate. What becomes apparent in the sign systems for virgin is the idea that seclusion for the tribal woman begins the process of rebirth from child to adult. She is in the state of becoming a mystical, magical creature with the power to create new human life from her own body. In matri-focused societies, she was isolated out of reverence and awe toward the physical and spiritual processes evolving in her own body; in patristic society, she was isolated out of fear and dread toward a power uncontrolled by man and, hence, dangerous to him.

If mythologies are indeed internal dialogues of body organs, if ancient people interpreted the twisting and turning intestines of the bowels as the birth canal,[9] then the idea of the labyrinth in myth becomes a descent toward the rebirth of the hero. If this idea is applied to the female journey of self discovery, then it is she who descends, like Inanna, into the labyrinthine depths of her own physical body. When male heroes begin their adventures, they arm themselves with the weapons necessary for their battles. When female heroes begin their adventures, they take conscious possession of their own creative potential: Eve accepts the apple, Pandora has her box, Persephone gathers her flowers, and Red Riding Hood has her basket of goodies given to her by her mother. More openly and to the point, Inanna, in the ancient poem "Inanna and the God of Wisdom", celebrates her "wondrous vulva"[10] before she sets out by herself on her adventure. For the male hero, the descent into the labyrinth is the descent into the "other"; for the female hero, it is a descent into self.

The Adventure of Choice

The archetype of rebirth is initiation.
Nor Hall

Within most of our own Western patriarchal heritage, there are no rites and rituals concerning the onset of the menses. Because of the patriarchal conscriptions about the pollution and uncleanliness of a woman's period, this rite of passage is usually met with horror stories about the "curse" or lectures about the inconveniences of being an adult, or complete isolation from the social group for the menses' duration. Many young women feel embarrassed or shamed about something that should be looked upon with great joy and pride. Whatever rites and rituals that existed in matri-focused societies were replaced in patriarchy with menstrual taboos. The rationale of the isolation hut as a place for personal contemplation was reinterpreted to be a place of punishment and imprisonment against a natural process uncontrolled by man;

> Elizabeth Gould Davis, who theorizes that matriarchies were the world's first political systems, sees the female-blood taboo as a vestige of the time when the ruling women used the taboo to make men respect and fear women.[11]

We have seen in previous chapters that patriarchy assumes the power of birth and creation through the discovery of paternity and the development of the Father God. As women and children were reduced to chattel and property, so too were the processes that made children possible taken under patristic control. Hence, the menses cease to be a natural function of woman's body and become instead a curse bestowed on women for the crime of being women.

Within the patriarchal rewrite of mythology, women like Eve Pandora, and Persephone are given their menstrual "gifts" by their

respective patriarchal gods rather than receiving them as part of a female inheritance by their absent mothers. Each gift has distinctly feminine symbolic overtones: the apple, for matristic societies, is the embodiment of the Goddess; when it is cut crosswise, the seeds resemble a pentacle, a symbol of the Goddess and her wisdom; the box given to Pandora is the symbolic womb, for the word "box" itself is a common euphemism for a woman's reproductive organs; the pomegranate seeds of Persephone are contained in a fruit that is also symbolic of the womb. Persephone is abducted by Hades while she gathers flowers, symbols which have a decidedly "menstrual significance."[12] Even Hera in her virginal aspect was sometimes called "*Antheia* ('flowering one'), symbol of both the flower of human youth and the budding earth."[13] Sometimes the onset of menses is depicted as a symbolic bleeding, such as Sleeping Beauty pricking her finger on a spindle (note that it is a female villain who posits the deadly spindle in Sleeping Beauty's way, indicating the patristic view of the negativity of feminine inheritance). In the Nahuan myth from ancient Mexico, Itzpapalotl, the goddess of the soul symbolized by a butterfly, pricks her finger on a thorn while trying to pick flowers; "Ever afterward, she made sure that humanity paid well for its pleasures, just as she had to pay for her rose with her blood."[14] Instead of the celebration of the womb as the repository for the potential of life, these gifts only exasperate the mortal woes of humanity. Menses thus becomes a curse instead of a blessing; and woman's being a creation of man becomes reenforced.

In order to get some idea of how the matristic rites of menarche must have functioned before patriarchy, we return to the story of Inanna and the god of wisdom, Enki. Alone, Inanna begins her journey, as we have said, with a celebration of her vulva:

> When she leaned against the apple tree, her vulva was
> wondrous to behold
> Rejoicing at her wondrous vulva, the young woman Inanna
> applauded herself.[15]

She declares her intention to pay homage to Enki, the god of wisdom, in his sacred place the Abzu. In this Sumerian text, the deity for wisdom is already identified with a male god, but as Marija Gimbutas

states, "the Goddess Ninhursaga, one of the most powerful deities of the 3rd millenium B.C. ... was supplanted by the male Enki in the 2nd millenium."[16] If we follow this identification, then Inanna is paying homage to Ninhursaga, the creator of human beings, who is depicted as a divine cow with milk which nurtures royalty and imbues them with her holy wisdom.[17] Often in stories with virginal characters, there is an initial relationship with an older woman, either grandmother, fairy godmother, witch or hag, that imparts a special wisdom or direction to the hero and gives purpose to her journey, as well as reenforces the continuum of female inheritance. In ancient Greece, for example, before a young woman could establish her own home, fire from her mother's hearth was brought to consecrate the new house for the goddess Hestia.[18] The virgin and the crone are always connected in the circuitous nature of woman's existence.

As Inanna approaches Enki's sacred place, Enki calls for his servant to prepare a table for them; the two then sit at the table and begin to drink beer. Every time their glasses are raised, Enki toasts Inanna and gives her another part of the sacred "*me*" which consists of the "attributes of civilization" that "were derived from and inspired by the gods and made available to the people through the institution of the temple and its servants."[19]

> (Fourteen times Enki raised his cup to Inanna.
> Fourteen times he offered his daughter five *me*, six *me*, seven
> *me*.
> Fourteen times Inanna accepted the holy *me*.)[20]

Inanna then repeats all the components of the sacred *me*, finishing the list with the final gifts of, "counseling...the giving of judgments...[and] the making of decisions."[21] With these, Inanna prepares to leave and loads the *me* into her boat.

> Although most of the *me* stress the power and importance of
> the priesthood and servitude, without "the making of deci-
> sions" the other *me* are meaningless. Without the individual's
> decision there can be no kingship, leather-making, princess/
> priestess, counseling. It is the will that perceives, believes,
> and takes action.[22]

"When the beer had gone out from the father Enki,"[23] he realizes that he has given Inanna everything and must regain the sacred *me*. He sends his servants after her, but Inanna refuses to submit. Instead she calls on her own servant Ninshubur to protect the *me*, which Inanna eventually takes back to her own sacred place, bestowing the *me* on her people. But as the *me* is being conferred on the people, magically more *me* appear. These components consist of "feminine attributes" which reflect Inanna's personal growth into a "fuller woman...from hero to queen."[24] They consist of "allure... the art of women... the perfect execution of the *me*"[25] and the art of music. At this point, Enki concedes Inanna's victory and allies her people with his own.

The idea of Inanna's sanctioning herself with the power of counseling, judging, and the making of decisions becomes of paramont importance for this rite of passage. She then balances these with the feminine attributes of administration, beauty, and music (which refer to the ordering and harmony of the universe through sight and sound). If we substitute Enki with the older creatrix of Sumerian civilization, Ninhursaga, then the story can be seen as emphasizing a female inheritance that is being passed down through generations of women. Decision-making then becomes the purpose for the woman hero to proceed on her journey of self discovery; "She symbolizes the feeling capacity to evaluate, periodically and afresh, that goes with the sense of life as a changing process."[26] By taking conscious control of her body and her spirit, the virgin Inanna can effectively direct her life. She is ready now for the next chapter of her story, the next passage into maturity. To see the onset of the menses as an empowering rather than a debilitating occurrence is to confer the gift of decision-making to a young woman. The responsibilities inherent in her choices must be made clear so as to allow her the power of choice.

As Nor Hall points out, it is interesting to remember that the word *menses* is related to the word for moon, as well as to the words "month" (*mensis*), "heart, spirit" (*menos*), "possession" (*mania*), "to prophesy" (*manteia*), "to meditate" (*menoinan*), "to reveal" (*menuo*), "to remember" (*memini*), "wisdom" (*metis*), "to dream" (*metiesthai*), and "to measure"

(*mati-h*).[27] All of these words can be related in some way to the adventures of Inanna, indicating the close connection to the phases of the moon, the onset of menses and the beginning of the journey of self actualization. Because the presence of the menses was considered necessary for the nourishment of the fetus, ancient people all over the world thought of it as the ambrosia of "longevity, authority, and creativity."[28] Primitive burial rites included painting the dead body with red ocher as symbolic of menstrual blood for the purposes of rebirth. The fluid that filled the Grail initially may have been this same "blood of the moon."[29] The stories of Inanna and Persephone emphasize the shift from matristic to patristic philosophy with the intrusion of Enki and Hades, respectively, into the storylines. Even though Inanna accepts the gifts of Enki and makes the conscious choice to keep them, in the Sumerian pantheon, Enki, the god of wisdom has already replaced Ninhursaga, the goddess of wisdom, who preceded Enki by thousands of years. With Persephone, too, it is Hades who appears on the scene and forces her away from the flower filled, daylight world of her mother. Persephone's story, coming to us from the Homeric hymns compiled in the seventh century b.c.e., indicates the intrusion of patristic politics into the mythical storyline of feminine descent;

> Whatever the impulse behind portraying Persephone as a rape victim, evidence indicates that this twist to the story was added after the societal shift from matrifocal to patriarchal, and that it was not part of the original mythology.[30]

In her essay entitled, "The Myth of Demeter and Persephone," Charlene Spretnak imagines what the story might have been like before patriarchy's rewriting of the myth.[31] In her version, Persephone descends because she hears the call of the underworld and, like Inanna, she decides to willingly embark on her own journey. What Spretnak does, what many feminist scholars continue to do, is take back the myth. This reappropriation of stories that once held mystical significance for the psychological and spiritual development of woman redefines woman's place within herself as well as within her world, enabling women to realize that the apple, the box, and the pomegranate seed were ours to begin with.

The menses is not a choice for the individual woman; it is a physical occurrence that begins as a biological process of maturation toward adult womanhood; however, the objectification of the woman in patriarchy causes a separation to take place between the body and the mind (soul or spirit) of the female;

> The existing body of feminist theory is so rich and varied and has raised so many issues around the consequences to women of the mind/body split that it argues powerfully for all future feminist theory to be firmly grounded in an understanding of the body's role in cognition.[32]

What has been lost in thousands of years of patriarchal management is the concept of viewing the menses as an adventure that initiates personal choice and decision. The young woman becomes a sexual creature with the power to choose whether or not she will engage in sexual activity and with whom. In patriarchy, however, that choice has been usurped by the dominant male, her choice of sexual/marital partners taken away. In redefining the virgin status as her own, the idea of choice becomes predominant. It is her choice to accept the adventure of maturation, to celebrate her own inner depths in defining herself as a woman.

With the understanding of the responsibility of choice, comes "the right to choose what to do with her own body, whether to roam at will or to stay home, whether to practice celibacy or engage in sexual activity."[33]But those choices cannot be made without the education needed to make an informed decision. When patristic society hinders or obstructs woman's access to educational materials about her own body, then the options are severely limited; woman herself becomes severely limited when her body, no longer her own, becomes the goal or the prize for the adventuring male hero. Only through the redefinition of the virgin state can woman find the resources to choose to be the hero of her own adventure beyond the societal conscriptions of patriarchy, beyond the limitations.

Sexual Initiation

To a woman the first kiss is the end of the beginning;
To a man it is the beginning of the end.
Helen Rowland

One of the choices most women eventually make has to do with sexual initiation. In traditional fairy tales, Snow White, Sleeping Beauty and Cinderella all disappear as soon as their handsome princes rescue them from their troubles for a future of "happily ever after." The female characters themselves are replaced as heroes by the males who choose to rescue them. As happily ever after as they may live, these women are chosen by their respective princes; the virgins' own participation at the height of their adventures is completely passive. The power of decision and action is usurped by these knights in shining armor, rendering the females powerless, helpless, against the forces that press upon them. In contrast to this powerlessness in these traditional fairy tales is a mythic tradition in which the female remains the hero of her own adventure journey, even after the appearance of a male lover.

The initial sexual conjunction in myths can provide for personal growth (Psyche), power (Inanna), and control of an other realm different from her own (Persephone). In agricultural myths, sometimes the initial sexual conjunction causes new plants to come into being as in the legend of the coconut tree and the virgin Ina.[34] In hunting societies, sexual initiation can teach the social group about the performance of conciliatory rites for hunted animals[35] and the integrity of the ecological fabric shared by all earthly creatures. Sometimes, the animals presented in these myths represent human passions and drives; myths such as "Beauty and the Beast and its numerous derivatives in the 'animal bridegroom' genre are descended from a more ancient archetypal myth — the story of Cupid (Eros) and Psyche"[36] in which the female actively works through the conflicts to emerge victorious as hero.

The *hieros gamos* (sacred marriage) described in these examples of sexual conjuction can be traced as a prevalent concept from prehistorical times through the Middle Ages, and is still with us today. The idea of primary female and male forces coming together to create the universe corresponds to Campbell's four phases of developmental mythology concerning the creation of the universe myths. In the second phase of development, female and male come together to create the world anew: Ishtar and Tammuz, Astarte and Baal, Isis and Osiris, Cybele and Attis, Anahita and Mithra, Aphrodite and Adonis, all began as *hieros gamos*, sacred matrimonies:

> Through the power of the *hieros gamos*, the complete sacrifice of egotism and the possessive attitude towards oneself and one's own emotions and instincts which that ritual involves, is born this Hero-child, the ability to start again, even after disaster and failure and to start on a different level with new values and a new undertsanding of life.[37]

In Apuleius' *The Golden Ass*, there first appears the story about Psyche and her lover Cupid who will make love to Psyche only in the dark of night. Intrigued by her own curiosity (and that of her sisters) and fearing that her lover might be a monster, Psyche devises a plan in which she would be able to finally see her lover, but Cupid, awakening to find Psyche with an oil lamp, flies away from her. Destitute, Psyche cries to his mother Aphrodite for help in regaining her lover. Through a series of labors, Psyche learns to depend upon herself rather than on weapons of violence or murderous escapades that usually mark the adventures of male heroes. She learns compassion and humility as she undergoes these initiatory rites of passage. The last of her labors takes Psyche to the depths of the underworld to fill Persephone's beauty box (notice, the same uterine imagery) for Aphrodite so she may have "'[Persephone's] potion which maintains youth and delays the signs of old age'";[38] Psyche's descent becomes a return to the womb when she is instructed to descend eyes closed and feet first into a vent in the earth; this done, she should give a slight push to slide smoothly down a tube. When Psyche emerges successfully from the underworld, however, she opens the box (something she has been told not to do) and discovers Knowledge:

There was no beauty secret in it at all, nothing except sleep
and forgetfulness of all her past trials. Her love rescued her
and closed the box, which was given to Aphrodite.[39]

Psyche follows all of the instructions she has received, except this
last prohibition; her one act of disobedience marks her reliance upon her
own intelligence because of "her intuitive grasp of the fact that any
injunction against knowledge must always be disobeyed."[40]

It is at this point that Psyche becomes worthy enough to be reunited
with Cupid in marriage on Mount Olympus where their children Love and
Delight are born. As Psyche discovers knowledge, Eve eats the fruit from
the tree of the knowledge of good and evil, and Pandora opens the box
containing the secrets of life. These are not the weak and foolish mothers
of humanity; these are the women who themselves contain, and from
themselves discover, the knowledge of the human condition.

These stories, rich in allegorical and psychological symbolisms,
represent the development of feminine individuation through sexual
conjunction. What marks Psyche's story (or Eve's and Pandora's) as
unusual in the conventional realm of hero yarns is the lack of physical
weaponry, bravado, and pride and the emphasis on personal humility,
dependence on the self and one's own intuition. Psyche's quest is one of
knowledge, not power. What Psyche, or the fairy tale Beauty, receives in
her adventures is her "own personal autonomy and empowerment, [a
sense of] possession of herself; and in coming to love herself, the fear of the
'Other' dissolves, [and] the Beast becomes a friend."[41] It is this sense of
meeting the "other", that the young woman comes to terms with her own
concept of "self-esteem, self-definition, and self-responsibility."[42] The
virgin then emerges as one who is "belonging to no man," "one-in-herself";
"she may give herself to many lovers, but, like the moon, she can never be
possessed"[43] because self possession is hers alone:

This is the wisdom of the dark feminine that Psyche... was
to bring to Aphrodite, the Greek Inanna, to make her
beautiful and eternal.[44]

This is the possession of self that patriarchy sought to destroy by
removing choice and self determination from women. It is the same
possession of self that we seek to return to ourselves and to our daughters.

Good Girl, Bad Girl: The Dichotomy of Self

*(The Perpetual Virgin or
How to Get Stuck in an Archetype)*

We have seen how the advent of the patriarchal social system radically and dramatically altered the perceptions of female archetypal images into a stark dichotomy of good versus evil. Thus, while the Goddess was both the giver and taker of life in matriarchal philosophy, she now became only the taker of life, like Lilith, while the male god assumed the power to give life through the assumption of the powers of creation. While males saw themselves as the "other" apart from nature, women became identified as only nature, with no spiritual, moral, or cognitive modes of thought. Man became the spiritual creature; woman, the animal creature. What was perceived as holy and sacred belonged to realm of the male; what was perceived as animal and natural belonged to the realm of the female. This kind of opposition leaves woman without the moral aptitude to make ethical or moral judgments, placing her in a subservient role (just as nature becomes subservient to culture) from the higher, more spiritually developed male. For a female to emulate the male, she would have to give up her animal or sexual nature almost completely; as long as her sexual nature becomes apparent only within the male codified form of marriage, it is allowed for procreative purposes; a female who indulges her sexual nature without the construct of marriage, however, is identified only by her animalistic tendency. Therefore, only virgins with an asexual purity could be identified as good, while those with active sexual adventures could be identified as bad or dangerous to the male (the old virgin/whore dichotomy).

As all archetypal images became dichotomized between good and bad, so too the virgin, whose once rounded character now gave way to one extreme (virgin) or the other (whore). Examples of the virginal character

can be seen throughout literature, myth, and popular culture. Good virgins, who are almost asexual in their purity, range from Cassandra, Creiddylad, Daphne, Antigone, Psyche, Ch'ang-O, Alice in Wonderland, Dante's Beatrice, Mary (as virgin), Eliza (in Shaw's "Pygmalion"), Red Riding Hood, Onatah, Dorothy (in *The Wizard of Oz*), Snow White, Shin-Mu, Cinderella, Olwyn, Sleeping Beauty, Arachne, Princess Leia, Rapunzel, Tinkerbell, Selene, and Artemis.

Their color is white for purity, and although they may have red ruby lips, they are not allowed to use them. What further distinguishes the good virgins from mortal women is the degree of their passivity; most of these heroes are acted upon (Sleeping Beauty); or they react to forces which act upon them (Antigone). They don't usually initiate their own adventures; circumstances force them into situations from which they must extricate themselves, sometimes alone, but most often by the means of a helper or helpers (Dorothy, Princess Leia, Cinderella, Tinkerbell). They love purely in the traditionally maidenly manner; their princes usually bestow a kiss or, at least, propose marriage as the honorable social unit. In either case, the hero is removed from any further adventures by the male.

As very, very bad girls, whose sexuality is seen as dangerous or life-threatening to males, we find Phaedra, Philomel, Aphrodite, Guenevere, Eve (as temptress), Katerina (in "The Taming of the Shrew"), Helen of Troy, Ate, Madonna (of rock 'n' roll fame), Circe, vamps of the silver screen like Theda Bara, Marilyn Monroe, any or all of the Playboy Bunnies, Nix, Grainne, Blodeuwedd, Pandora, Diana (especially during the Middle Ages), Lorelei, Mary Magdalene (before conversion), and other young prostitutes and "fallen women."

These beautiful virgins have an erotic appeal; their disguises are used to destroy. Sensual creatures, like the Sirens who lure innocent males to their doom, are manipulative; they can hypnotize a man away from his comrades (Guenevere) or from male allegiance (Blodeuwedd); they can cause nations to war against each other (Helen of Troy), or destroy the trust between a father and his son (Phaedra, Grainne). They are responsible for loosing evil into the world because of their own curiosity (Pandora, Eve), and they may even consort with the Devil

himself (the medieval Diana). In any case, certainly not the girl to bring home to one's parents.

Sometimes sister relationships define the good and the bad aspects of what was probably the same female before the process of patristic fragmentation split them into two aspects, for example, Inanna and Ereshkigal. The two together symbolize transformation, "the bipolar wholeness pattern of the archetypal feminine,"[45] the end and the beginning all wrapped up in one terrifying metamorphosis of the self. Other examples of mythological dynamic duos are Hathor and Sekhmet, Amaterasu and Uke-Mochi, Frigg and Freya, Ganga and Uma, Isis and Nephthys, Pele and Namaka, Dennitsa and Vechernyaya, and Utset and Nowutset. In these cases, one is always representative of light or good and the other personifies the evil or darkness. These sisters usually meet in the process of descent or seem to work against each other's purposes. But they can also symbolize "a return to the possibility of being intimately reconnected to an other who is like herself and who can, therefore, validate her fully."[46]

Another motif, especially seen in mythology and Arthurian romances, is that of the rape and/or murder of the female. This motif usually represents the violent take-over of matriarchal goddesses by patristic forces, exemplified by Campbell's third developmental phase of mythology wherein the goddess is violently destroyed by the male god: Artemis is raped by Apollo, Britomartis is raped by Minos, Daphne flees the rude advances of Apollo and finally turns herself into a laurel tree to escape him, Kaikilani is murdered by the Polynesian Lono, Kara is murdered by Helgi, and Pythia (considered a "menstrual priestess")[47] is murdered by Apollo as part of his take-over of the Delphic oracle.

There are also several virginal goddesses who personify both love and war: Athena (Minerva), Chiu T'ien Hsuan-Nu, Scathach, Ishtar, and Medhbh (Maeve or Queen Mab) who "stopped a battle by showing that she was menstruating,".[48] The linkage between love and war may also be a vestige of the battle between the sexes that ended the era of matriarchy and began the reign of the phallus. This same linkage can also indicate the battle inherent in keeping one's integrity intact within a love relationship

that threatens individuality with the blending of two souls into one unit. Love and war then become analogous to the dialogue between desire and self-denial.

Because of this dichotomy between good and bad as defined by their sexuality, women have been constricted, contracted, and controlled as a way of ensuring their purity and, thus, the purity of the society. But, this dichotomy can be empowering when understood to be a part of the female quest for self that is begun as an "initiation into adulthood... entry into marriage and social involvement, quest for sexuality...[and] personal transformation."[49] The purpose of the descent into the self is to unify the two divergent elements of mind and body, Psyche and Eros, to gain the capacity of choice and the authority of decision. If "the archetype of rebirth is initiation,"[50] then the archetypal virgin's descent begins the process of self actualization for the female.

The virgin's purpose is not simply to become the consort of the male hero, nor is she only the goal of his adventure quest. She has a journey of her own, one that is filled with all the excitement and terror that new discovery always entails:

> Women's rebirth journeys... create transformed, androgynous, and powerful human personalities out of socially devalued beings.[51]

The Eros of myth is her Eros which springs "from the inner realm of unconscious experience [which] demands the capacity for moving down into and returning from the deepest realms of the libido."[52] The virgin becomes her own woman, belonging to no man, owing no allegiance except to herself, accepting all responsibility inherent with her choices and decisions.

We have begun the first part of our journey:

> We, coming early to culture, repressed and choked by it, our beautiful mouths stopped up with gags, pollen, and short breaths; we the labyrinths, we the ladders, we the trampled spaces; the stolen and the flights—we are 'black' and we are beautiful.[53]

Notes

1. Merlin Stone, *When God Was A Woman* (New York: Harcourt, Brace and Jovanovich, 1976) 196.

2. Stone 60.

3. Naomi Goldenberg, "Archetypal Theory and the Separation of Mind and Body," in *Weaving the Visions: New Patterns in Feminist Spirituality,* ed. Judith Plaskow and Carol P. Christ (San Francisco: Harper & Row, 1989) 196.

4. Annis P. Pratt, "Spinning Among the Fields: Jung, Frye, and Levi-Strauss and Feminist Archetypal Theory," in *Feminist Archetypal Theory: Interdisciplinary Re-Visions of Jungian Thought* (Knoxville: University of Tennessee Press, 1985) 109.

5. Joseph Campbell, *The Hero With a Thousand Faces* (Princeton: Princeton University Press, 1968) 30.

6. Janice Delaney, Mary Jane Lupton and Emily Toth, *The Curse: A Cultural History of Menstruation* (Urbana: University of Illinois Press, 1988) 28.

7. Elinor W. Gadon, *The Once and Future Goddess: A Symbol for Our Time* (San Francisco: Harper & Row, 1989) 153.

8. Marija Gimbutas, "Women and Culture in Goddess-Oriented Old Europe," in *Weaving the Visions: New Patterns in Feminist Spirituality,* eds. Judith Plaskow and Carol P. Christ (San Francisco: Harper & Row, 1989) 68.

9. Barbara G. Walker, *The Women's Dictionary of Symbols and Sacred Objects* (San Francisco: Harper & Row, 1988) 308.

10. Diane Wolkstein and Samuel Noah Kramer, *Inanna: Queen of Heaven and Earth* (New York: Harper & Row, 1983) 12.

11. Delaney, Lupton, Toth quoting Elizabeth Gould Davis 8.

12. Delaney 190.

13. Patricia Monaghan, *The Book of Goddesses and Heroines* (St. Paul: Llewellyn Press, 1990) 153.

14. Monaghan 180.

15. Wolkstein 12.

16. Marija Gimbutas, *The Language of the Goddess* (San Francisco: Harper & Row, 1989) 110.

17. Barbara G. Walker, *The Women's Encyclopedia of Myths and Secrets* (New York: Harper & Row, 1983) 727-28.

18. Monaghan 155.

19. Diane Wolkstein, "Interpretations of Inanna's Stories and Hymns," in *Inanna: Queen of Heaven and Earth*, by Diane Wolkstein and Samuel Noah Kramer (New York: Harper & Row, 1983) 147.

20. Wolkstein, *Inanna* 15.

21. Wolkstein, *Inanna* 18.

22. Wolkstein, "Interpretations" 148.

23. Wolkstein, *Inanna* 19.

24. Wolkstein, "Interpretations" 150.

25. Wolkstein, *Inanna* 26.

26. Sylvia Brinton Perera, "The Descent of Inanna: Myth and Therapy," in *Feminist Archetypal Theory: Interdisciplinary Re-Visions of Jungian Thought,* eds. Estella Lauter and Carol Schreier Rupprecht (Knoxville: University of Tennessee Press, 1985) 145.

27. Nor Hall, *The Moon and the Virgin: Reflections on the Archetypal Feminine* (New York: Harper & Row, 1980) 10.

28. Walker, *Encyclopedia* 636.

29. Walker, *Encyclopedia* 352.

30. Charlene Spretnak, "The Myth of Demeter and Persephone," in *Weaving the Visions: New Patterns in Feminist Spirituality,* eds. Judith Plaskow and Carol P. Christ (San Francisco: Harper & Row, 1989) 73.

31. Spretnak 72.

32. Goldenberg 247.

33. Pratt 110.

34. Joseph Campbell, *The Masks of God: Primitive Mythology* (New York: Penguin Books, 1987) 198.

35. Campbell, *Primitive* 282.

36. Madonna Kolbenschlag, *Kiss Sleeping Beauty Good-Bye* (San Francisco: Harper & Row, 1979) 159.

37. M. Esther Harding, *Women's Mysteries: Ancient and Modern* (Boston: Shambhala, 1990) 154.

38. Norma Lorre Goodrich, *Priestesses* (New York: Harper Collins, 1989) 232.

39. Goodrich 234.

40. Goodrich 235.

41. Kolbenschlag 161.

42. Kolbenschlag 217.

43. Hall 11.

44. Perera, *Descent* 33.

45. Perera, *Descent* 43.

46. Perera, *Descent* 46.

47. Janet and Stewart Farrar, *The Witches' Goddess* (Custer: Phoenix Publishing, 1987) 263.

48. Farrar 246.

49. Pratt 168.

50. Hall 24.

51. Pratt 142.

52. Pratt 74.

53. Helene Cixous and Catherine Clement, *The Newly Born Woman,* trans. by Betsy Wing (Minneapolis: University of Minnesota Press, 1975) 69.

III. The Mother

Few concepts in the history of humanity have generated more controversy than the concept of motherhood. Even the definition of *mother*, linked as it has become to today's high-tech, modern medical laboratories, has become problematic. Is motherhood a state of biology or psychology? Can it be duplicated in an artificial setting? Do surrogate mothers merely provide an environment for fetal growth? Can lesbians or homosexuals be effective mothers? How about mentally deficient people? Can a man mother? Since the trial of Orestes for matricide in *Eumenides* the concept of motherhood has been structured and restructured to serve the individual society. It has been decried, studied, defied, blamed, sanctified, canonized, vilified, and deified, and still the essential meaning of motherhood for women has evaded our grasp. Does any individual woman have the right to determine when to have a baby? Or does society have the right to force any individual woman to carry a fetus to term whether or not she wants it?

We must always keep in mind the fact that the majority of women in today's world, as throughout patriarchal history, do not have the essential right to control their reproductive capacities. Women who have access to effective birth control and abortion are in the minority; most do not. For them, pregnancy becomes a condition imposed on them from without rather than an internal, personal choice made for themselves. As Apollo decreed at Orestes' trial, woman is simply soil for the man's seed, mere vessel for nourishment. Today, in our own society, there is an ongoing ethical and moral debate concerning the practice of surrogate motherhood wherein a woman will agree by contract to carry a fetus to term for another couple seeking to have a child. The problems inherent in such a contract are sparking a tremendous controversy: who should be

considered the legal parents? Does the surrogate have any rights toward the child born from such a contract? What if the surrogate should change her mind? Ellen Goodman comments, "We can ask whether pregnancy is just another service industry."[1] If women do not have the right to control our own bodies, then we have no rights at all.

We still, however, have the problem of defining motherhood. I will offer my own interpretation which does not purport to be the all encompassing or final word on the subject. But for my own purposes, I will employ a definition of motherhood that is more psychological than biological, more a state of mind than a state of physicality, and hence, equally a state of culture and a state of nature, and more a condition of empowerment than a case of weakness. To be a mother, in this sense, is to accept personal responsibility for the present as well as for the future; it is a commitment to a society or a social group to improve the condition of its humanity, and to ensure its perpetuation for another generation. It is an acceptance of human mortality and a celebration of its endurance: "Being a mother, then, is not only bearing a child — it is being a person who socializes, and nurtures."[2] Motherhood is a tremendously difficult undertaking made worse by the fact that most societies through the ages have failed to educate its members to its importance. Perhaps that is why so many women cling to the idea of a matrilocal social group that would empower and deify women who are mothers rather than enforce the idea of motherhood as servitude to the patriarchal state.

Can anyone be a mother? Yes, lesbians, homosexual and heterosexual men, women who adopt, women who choose to give birth, women who are forced to give birth, women who choose to remain childless can all achieve motherhood if motherhood means nourishing and investing in the present for a better survival in the future. So when I speak of a woman who gives birth, I ask my readers to understand the concept metaphorically as well as physically; any and all women can give birth: to ideas, to art, to politics, to new social orders, to revolutions in politics and culture, to children, to codes of ethics and behavior.

The Transformation of Conception

Every woman extends backward into her mother and forward into her daughter.
C.G. Jung

The Goddess Mother not only rules over the fecundity of nature but entails within her the beginning of life, life itself, and its ending. From woman is one born, nurtured, socialized, and into woman is one buried after death for the purposes of rebirth. In this sense, then, the Mother Goddess becomes a complex figure, both solicitous and threatening, life-giving and life-taking: fecund and sterile. Her body births the universe, and into her body she receives her dead.

In terms of the hero's journey, the virgin begins the descent into self, but the mother continues the process of self development by enriching the personal dialogue begun by the virgin between desire and self-denial. What is added at this point is the social context of the adventure. Unlike the virgin, the mother exists within and for her social group whose very survival is dependent upon propagation and cooperation. In terms of the hero's adventure, the mother represents the warrior; she creates, defends or destroys, and emerges intact. She becomes the social context of humanity, preserving and improving society through the children she bears:

> The mysteries of creation, transformation, and recurrence — the primal mysteries of all religions — emerged from women's direct physical and psychic experiences of these mysteries: in bleeding, in growing a child, in nursing, in working with fire, in making a pot, in planting a seed.[3]

In the earliest of creation myths, the Mother creates alone from her own body. She is the sky, the earth; her children are the plants, the humans, and the animals. She is the lush growth of summer and the full moon. The mountains are her breasts and the sea her primal birth-giving waters. In the beginning, it is she who creates the universe. The images of great cosmic eggs come readily to mind as the great Goddess Mother

begins the cycle of time from the void of an eternal chaos. Ammaveru of India and Eurynome of ancient Greece both create world order from cosmic eggs.[4] The virginal body may reflect the rhythm and cycles of nature, but the mother's body reflects the beginning of marked time and age as conception moves to fruition, as one body divides into two, as the end of pregnancy begins the life of another individual. The image of mother in the female trinity of virgin, mother, crone is the central anchor for the other two images. It is her adventure within the social context of humanity that woman's search for self and her battle for personal autonomy begins. The "one-in-herself" that the virgin comes to terms with in her passage is tested and retested during the phase of motherhood.

If the descent of the woman hero is a descent into the self, then the images of the life-giving womb become all important to the transformation and rebirth of the self to levels of higher understanding and conscious-ness. These images, which reappear throughout the ages, are depicted in mythology as labyrinths, mazes, and caves. For example, the caves of Lascaux and the labyrinth on the floor of the cathedral at Chartres are the same roadmap to rebirth through the body of the mother. Individuals who can follow the paths into the center and out again are rewarded with identities made stronger or begin higher spiritual understandings of their essential selves.

Wombs, vessels, eggs, cauldrons, ovens, labyrinths, and caves are all images of becoming. According to the research of Marija Gimbutas, the earliest Mother Goddess images reflected the mystery and magic of becoming through depictions of woman's reproductive organs as lozenges, swirls, concentric circles, waxing moons, egg motifs, and double axes, as well as images of women giving birth in squatting positions.[5] These images reflect the earliest myths of the creation of the universe as in Campbell's theory on the development of mythology; the earliest myths reflect the Mother Goddess as creating the world order alone and from her own body. Before the patriarchal epoch, the creation of the universe by the Mother Goddess was an active desire to create, to make, to fashion, to begin a new beginning; "Everywhere on earth there is a residue of a time when the generative powers of women were the basis of sacredness."[6]

After the onset of the patriarchal epoch, however, woman was relegated to a position of passivity while the male hero created new world orders by using or destroying the female's body, either actually as in the myth of Marduk and Tiamat or symbolically as in the myths concerned with killing dragons and monsters.

But in the earliest of agricultural myths, the idea or image of the egg coincides with the reality of the seed and vegetative growth:

> The wonder of the tree continues to exist today, for although we cannot explain the *first* seed, we can take the seed in our hand and say, here is the beginning of new life. It will emerge from the underworld, strive toward the heavens, and die back into the underworld, from which one of its descendants will emerge.[7]

And just as the seed and the egg are self-contained units of procreation, so too was the womb of woman thought to be self-contained. The earliest black goddesses were thought to be "bisexual creatures,"[8] harboring within their bodies all of the powers of fertility needed to create life. Because the ancients believed that menstrual blood was the source of life and because that same blood ceased to flow during pregnancy the correlation was made that during pregnancy, the menses coagulates to form the new human being. The red of the blood and the white of the milk produced through lactation together became the essence of life mixed within the cauldron of the womb. This primitive perception later developed into the pseudo-science of alchemy wherein the red and the white mixed in the egg-shaped vessel to produce the "Glorious Child."[9]

These are decidedly active powers fueled only by the goddess's will and determination to create from her own body. In the past, many images of the passive woman upon whose body creation is accomplished through male, and only through male, design emerge to enforce or reenforce the patristic assumption of female passivity in regard to creation. Zeus himself raped countless numbers of maidens to ensure the birth of his own heroic sons who soon took precedence over their most unfortunate mothers; Zeus even assumed the powers of creation for himself, birthing Athena from his head and Dionysus from his thigh. The traditionally

interpreted jealousy of Hera can be readily understood as righteous anger if those same myths are retold as patriarchal destructions of matri-focused orders. For women, the active response to conception and creation, which existed long before patriarchy, soon turned into enforced passivity as women were seen as possessions, mere brood mares who provided the androcentric state with its sons.

The importance of an active response to creation cannot be overemphasized enough in terms of woman's journey for self actualization. If the hero is to embark on her adventure, she must first have conscious control of her mind and her body. The choices, as have been demonstrated with the virgin, are hers at the beginning of the journey. To remove the option of choice is to limit and hamper the hero by depriving her of full control over her own being. The idea of women choosing whether or not to give birth, the time, the place, and the methods employed is still, in the late twentieth century, a radical idea. And although there are privileged women in the world today who can make these choices for themselves, we must never lose sight of the fact that they are in the minority. Most women do not have these basic rights and choices available to them. If we want to see woman as hero, we must first remedy her as victim.

Birth as Threshold

Pregnancy and childbirth are as close to dying as any other human experience.
Penelope Washbourn

Creation does not have to indicate creation of a child, just as motherhood does not have to indicate a woman who has given birth from her own body. The case has been brilliantly made by anthropologists and sociologists that the basis for human culture was created by women: time measurement, language, fire-making, pottery, storehouses, herbal medi-

cines, basket-weaving, cooking, domesticated animals, early social organization, and agriculture can all be linked to matri-focused orders and woman's ingenuity. Noted anthropologist Evelyn Reed writes that this "fusion of maternity and labor" led to the equation of the word "'mother'" with "'Producer-procreatrix'" in primitive language.[10] It wasn't that women had all this time on their hands (as anyone who has ever taken care of small children will attest); it was that a necessity was identified, then remedied, lending truth to the old adage of necessity being the mother of invention:

> Whether she bore children or not, as potter and weaver she created the first objects which were more than objects, were works of art, thus of magic, and which were also the products of the earliest scientific activity, including the lore of herbs and roots, the art of healing and that of nurturing the young.[11]

The creation of objects and systems points to a recognition of necessity's outliving one individual lifespan. M. Esther Harding writes that creation "can be assimilated in the individual... creating... a spirit that is immortal."[12] The social context of the earliest cultural advances made by women cannot be ignored, for within this social context lies the concept of mother emerging as the guardian and perpetuator of the human species; "Woman did not simply give birth; she made it possible for the child to go on living."[13] People, language, and culture allow for that perpetuation; it is the transformation from raw materials into employable utilities.

This transformation of matter, whether it be life itself or the transformation of raw materials into something useful for society, is defined by Adrienne Rich to be the "transformative power"[14] of motherhood; clay as vessels, threads as fabric, sounds as language all reflect this generative power of women. They also reflect the sense of necessity that extends from the here-and-now of the present moment into a future time of preparedness. The storage of seed and food stuffs, the expectations of seasonal growth and fecundity, the recognition of the patterns inherent in the turning of the sky were passages marked by women in an acceptance

of the ongoing nature of time. The death of an animal or plant allowed for the sustenance of human life; the death of winter allowed for the life of spring; "In matriarchal symbolism, many scholars point out, night is said to precede day and winter precedes summer, while in patriarchal societies the opposite is usually the case."[15] It seems like a subtle shift of attitude, but that is not the case; it means the difference between one social order and another. To understand that from death comes life places the entire concept of death into a positive context. For women, this was easy because women were seen as recreating themselves through the birth of their daughters. Women, then, were linked to the concept of immortality through their bodies and the power to give birth; men could not achieve the same procreative powers until after paternity was understood.

In terms of the hero's journey, motherhood becomes the link between the individual and society. She alone must concede the importance of the social context and must balance the needs of the group with the autonomy of the individual. When this balance is lost to either extreme, both society and the individual lose out; if woman is concerned only with herself, society suffers a breakdown in group cohesiveness; if she loses herself completely in the service to society, then she forgoes personal autonomy and she belongs only to society. The balance is delicate, but it must exist if both the individual and society are to progress beyond the present moment. It is no coincidence that Maat was the Goddess of truth for the Egyptians; it was she who held the balance scales that would weigh the individual's heart after death to discern whether it was weighted with justice or with evil:

> Maat was [also] the word for both "mother" and "matter"; it was the primordial mud of the Nile from which life grew. It also meant "truth" and "justice" and was often symbolized both as a feather and a vulture — the feather weighed in the balance scales against the soul at death, and the Vulture-Mother who swoops down to pick the dead bones clean for rebirth.[16]

The idea of death preceding new life emphasizes the transformation that takes place at the moment of birth. In the opening quotation for this section, Penelope Washbourn writes that "Pregnancy and childbirth

are as close to dying as any human experience."[17] The woman dies to herself as an individual and becomes two: a small society. Her main concerns after birth are nurturing the child and then socializing the child into the larger group with a sense of indebtedness and responsibility to the ongoing nature of society. She imbues the child with language and a sense of shared culture, custom, ritual, and history, thus epitomizing the connection of the present moment to the past as well as to the future; hence, mother's central position in the trinity of virgin, mother, crone. To do this, she must be willing to sacrifice a portion of herself to the new life she has created; she is no longer "one-in-herself": this one has now become two.

Birth and death used to belong completely to the realm of women. Nowhere is this more perfectly expressed than in the story of Inanna's descent into the underworld, a descent myth which "has reverberations concerning a central mystery of feminine experience, pregnancy."[18] In this myth, Inanna responds to the call to visit her sister Ereshkigal, queen of the underworld, to pay her tribute with sisterly compassion. Inanna moves from the "Great Above" to the "Great Below,"[19] abandoning her temples and priestesses, and taking up all of the regalia associated with her queenship and Sumerian culture. She tells Ninshubur, her "faithful servant,"[20] to watch for her return; if she doesn't come back as expected, Ninshubur is to raise her laments to Inanna's family in order to gain her release.

Inanna then proceeds on her journey to the underworld. At every one of the seven gates of descent, Inanna must relinquish another portion of her queenship until she finally appears before her sister, naked and unadorned, to face the wrath of Ereshkigal and her sentence of death. With one strike, Ereshkigal kills Inanna and hangs her corpse on "a hook on the wall."[21] After waiting three days and three nights, Ninshubur begins her lament for her mistress and tries to enlist help from Inanna's family for her release. She finally reaches Eridu, father to Inanna's mother, who agrees to help. He sends the "*kurgarra*" and the "*galatur*", both creatures who are "neither male nor female,"[22] with the food and water of life to the underworld. These creatures perform sympathetic

magic that parallels what seems to be Ereshkigal's own labor pains. When her pain is released through a rapport with the creatures, Ereshkigal allows them to reanimate Inanna's dead corpse with the food and water of life; Inanna rises and returns once more, "loathsome and claiming her right to survive,"[23] glorious in her queenship of the Great Above and the Great Below, having conquered and vanquished her own death.

Symbolisms abound in this myth; immediately recognizable are the connections of Inanna and her sister-image Ereshkigal, the three days and three nights of the death watch, the birthing pains of Ereshkigal, and the rebirth of Inanna as self made stronger through sacrifice. And although Inanna has had children before making the descent, it is the rebirth of herself that takes place within the context of her motherhood that becomes important to Inanna's journey toward self actualization.

Consider this passage from M. Esther Harding's book, *The Way of All Women*, in which she describes the process of birthing a child:

> Then when her hour comes she must give herself up to be merely the medium for this new life, her body merely the prison whose doors must yield to the violent assault of the being who would live free. In that hour the woman must experience *a gradual descent into the depths; the distinguishing marks of her personality, of her social grade, of her race, are stripped off, until she like her remote ancestress of old is revealed only as woman.*[24] [emphasis mine]

Harding goes on to say that birthing is a "terrible and humiliating ordeal" that brings women to "contact with the deepest meaning of life which has come to them by this road and by it alone."[25] Her description matches the ordeal of Inanna through her relationship with her sister-image Ereshkigal. The Inanna myth, according to Sylvia Brinton Perera, is the source "for renewal in a feminine sourceground and spirit" which is "a vitally important aspect of modern woman's quest for wholeness."[26]

We have seen with Inanna's adventures as virgin that, as the hero must, she has armed herself with the celebration and acceptance of her womanhood as well as the powers of decision and counselling, which were obtained through the *me* and bestowed upon the Sumerian people. But through the adventure with Ereshkigal, the hero Inanna descends into a

world quite different from her own. Once arrived, she must divest herself of all of the protective apparatus that defines her function in her daily realm. As Inanna suffers the humiliations and tests of courage and strength, she finally arrives at the purpose of her journey: the confrontation with another female of great power who challenges the hero. The sister-to-sister or mother-to-daughter relationship between Inanna and Ereshkigal brings together the divergent worlds from which each rules: Inanna as queen of the daylight world and Ereshkigal as queen of the realm of the dark. Taken together, they represent the conscious and the unconscious, the day and the night, the white and the black. They must face each other at some point naked and unadorned. Once Inanna acknowledges Ereshkigal's authority, then and only then can she rise unencumbered by her sister/mirror image. Once Ereshkigal is shown compassion for her own labor pains, she is willing to release Inanna. This reconnection of dualities serves to strengthen rather than weaken the individual; reconnection allows for the reintegration of the complex faces of woman into a maternal vision that empowers her with the capacity to shape her own destiny, to give birth to her own being. Symbolically or actually, the hero dies and is reborn into a new, stronger self image.

Inanna dies to Ereshkigal; Ereshkigal rebirths Inanna. The *galatur* and *kurgarra* exemplify "consciousness as empathy and mirroring"[27] that allows for the dissolution of the "osmotic membrane between child and mother, self and other, self and the gods... the place of crossing where two become one and one becomes two... The border is permeable, easily penetrated by empathetic sensing of the other, a capacity to feel and to share the other's emotional presence."[28] The peg Inanna hangs from symbolizes the suspension between the earth and sky, between the physical and spiritual on which the hero achieves passage from one level of self to another; the peg becomes transformation incarnate. Ereshkigal's birth pangs are also death pangs because in birth a woman dies to the "one-in-herself" as virgin and is reborn as mother with her child. Her experience demonstrates that "birth and death are intimates in the history of women, that change and pain are inevitable."[29]

A woman descends into labor and emerges as two. Only then can

she begin to understand the sacrifice of self she must undergo to allow that creation to take on a life of its own; yet she battles all through her maternity to preserve her self from complete absorption or destruction in this process of creation. Inanna retains her self and emerges stronger; Demeter gains a greater respect for her powers of regeneration from the gods, from even Zeus himself; Persephone becomes queen of the underworld, as does Lilith; the transformation of woman from virgin to mother becomes a transformation from personal autonomy to maternal warrior. It is no wonder that the Thesmophoric festival, which so embodied woman's rite of passage through the maternal phase of her life, began with the downgoing and uprising, the sacrifice of fasting or self denial, and concluded with the fair-birth or fair-born. It was a festival that sanctified woman's connection to her body, to her creations, and to her self as autonomous being.

The Maternal Warrior

Oh, what a power is Motherhood!
Euripides

Few forces on earth can match the ferocity of a mother protecting her young: Demeter caused the entire earth to remain under the darkness of winter until her daughter returned safely; Boedica waged a fierce war with the Romans to protect her daughters from rape; Hera incessantly defended her children and their rightful inheritance. In fact, the world is ringed with tales of the awesome and fierce mother warrior: Durga the Inaccessible, Juno Martialis, Ma-Bellona, Tauret, Tomyris. In addition to protecting their own children, mothers ensure the future for their particular society by reproducing the values important to that society. In the process, mothers develop a more relational role for themselves, linked as they are through that relational role to the social context.

Through maternity or motherhood, women learn the nature of self sacrifice for the betterment of the larger social group, and if they are successful, they teach that nature to their children. Nor Hall writes that "Birth always involves blood sacrifice."[30] The relationship between mother and child (or creator and created) involves a balanced sacrifice from both sides; if the mother/creator sacrifices too much to her creation, she becomes weak or ceases to exist altogether as a separate individual; if the child/created sacrifices too much, the child is unable to form an personal identity beyond the identification to the mother/creator. Neither can tyrannize the other; the balance is essential, and the attempt to balance must always be maintained for the successful, eventual emergence of the two.

Within the Thesmophoric festival of ancient Greece, the Downgoing and Uprising (*Kathodos* and *Anados*) are followed by the *Nestia*, or Fasting. It is within this context that self-sacrifice or self-denial becomes a part of the rites of passage for women to learn about themselves and their responses to the world around them. Self-denial becomes a tool of the spirit from which knowledge is achieved. The *Nestia* becomes symbolic for the transformation into motherhood, the negation of the self for a higher achievement or understanding, the sacrifice necessary for creation and the fight for its survival.

The nature of personal sacrifice is one of the essential ingredients in the male hero's storyline; he must learn personal sacrifice in order to emerge successfully from his adventures. Sometimes his sacrifice begins a new kind of society; sometimes his sacrifice simply renews societal commitments and values. In any case, he first struggles against the sacrifice and then nobly gives himself up for the betterment of the social ideal. The story of the male hero marks the individuation of that hero from the mother; the separation that must ultimately occur between child and mother:

> Children wish to remain one with their mother, and expect
> that she will never have different interests from them; yet
> they define development in terms of growing away from her.
> In the face of their dependence, lack of certainty of her

emotional permanence, fear of merging, and overwhelming
love and attachment, a mother looms large and powerful.[31]

It is that image of the large and powerful mother that becomes
almost overwhelming for the child. Breaking that bond becomes all
important if the integrity of the individual (from either side) is to be
maintained. For sons, it is the rejection, and sometimes, the destruction
of the "other"; for daughters, it means breaking the mirror of identification
that links daughter to mother. For the mother, however, it means the final
severing of the umbilical cord that connects the child to her body and soul.
And by doing so, she releases the child from its primary identification with
her. It is a most painful and difficult process for both sides, but a process
that must occur nevertheless. It is the sacrifice of the child.

And once that individuality is rescued, the hero must then reconnect
to the body of the society. The balance between the individual and the
collective must be renegotiated on the basis of adulthood. The breaking of
the parental bond may ultimately occur in adolescence, but the bond must
then be reestablished in young adulthood as the grown child comes to
terms with the greater society. The grown child then learns that a certain
portion of his or her individuality must be sacrificed for the good of the
social group. This element of social responsibility is what the myths of the
ages always stress; to be an adult in any social organization requires a
sense of responsibility to a larger good. The conflict inherent in the clash
between individuality and social responsibility is the stuff myths are
made of.

When the knight in shining armor slays the dragon, he is cutting
the umbilical connection between himself and the mother. Sons, who
experience gender differentiation, can readily see the mother as the
"other" from themselves. For daughters, however, the process is more
complicated. There is no gender differentiation, so the ability to see the
mother as the "other" doesn't easily take place. In a feminist reading of the
Snow White fairy tale, Shuli Barzilai presents the story as the conflict
between the mother and daughter as they struggle to separate as indi-
vidual beings.[32] In the same fashion, the conflict between Ereshkigal and
Inanna can also be presented as this struggle between mother and

daughter for self-definition. The mother may wish to absorb the daughter into herself, but the daughter must always struggle to escape the tyranny of the womb. Snow White and Inanna both emerge victorious and individuated, becoming sovereigns of their new realms as well as the realms previously ruled by their mothers. On the other hand, the dragon or the mother-monster being fought against seems to retain a kind of heroic aspect of relinquishment which allows the separation to take place. The mother knows and accepts what the child must do; given the initial power she has over the child, the mother makes a conscious decision to relinquish her control for the good of the child and society.

In any case, the separation that occurs in adolescence and the ultimate reconnection between child and mother allows for the social fabric to remain intact. Children eventually become adults and begin the process all over again with their own children. And just as the child-hero must renegotiate a relationship to the greater society based on a garnered maturity, the mother-hero must also renegotiate her connections to society based on the empowerment she has gained from motherhood. She is no longer the same individual who gave birth; her development through the experience of motherhood has changed her. Demeter does not remain alone for long after the disappearence of Persephone; instead, she takes a job with another household with "'women of [her] own age and even younger ones/ who will treat [her] kindly in both word and deed.'"[33] Inanna undergoes her magnificent transformation in Ereshkigal's realm after she had given birth to her children. The personal growth involved with these mythological goddesses points to a life beyond initial maternity allowing woman to assert herself and progress through the phase of motherhood to another level of self actualization.

The image of mother must be reinterpreted beyond the constraints of biology. But because mothers have always been the primary caretakers of children for the majority of societies, the conflicts inherent with their children are bound to be reproduced generation after generation. Although equalized parenting may be able to mitigate the conflicts somewhat, the adolescent separation between child and parent, which should allow for the individuation of both child and mother, must always take

place. But because we live in a patriarchal world, women will continue to "mediate between the social and cultural categories which men have defined; they bridge the gap and make transitions —especially in their role as socializer and mother — between nature and culture."[34] The difference is that, in taking back the myths which emphasize woman's development, woman can progress beyond motherhood and return to her own developmental progress.

Motherhood needs to be seen as a rite of passage for woman rather than an end in itself. Hardly any woman who undertakes the responsibility of creation emerges as the same person she was before the experience. So much emphasis is placed on the child or the created that the mother involved is rarely celebrated, rarely acknowledged, as a hero in her own right. The power of maternity is enormous; its influence can shape nations, begin revolutions, or sustain political states. And yet, motherhood is certainly a grounding for personal power and personal autonomy which allows for the passage of the individual through a stage of personal development.

The mother's role in the hero adventure is concerned with the social context between individual and collective. Motherhood represents the ability to retain autonomy over the self while, at the same time, being a part of a societal framework; "they [mothers] are continuously involved with issues of connection, separation, development, change, and the limits of control."[35] Within matri-focused cultures, women were the leaders, the decision-makers, the warriors who could ensure the survival of the social group. With the abilities of prioritization, organization, and delegation of authority, motherhood can again assume that same leadership role in ensuring survival for the human species.

Devoted or Devouring:
The Dichotomy of Self

Somewhere between the angel's white and the witch's
black, perhaps there's room for the other, more feminine
shades? The red of blood, of childbirth, of desire, of love.
Christiane Olivier

It is no wonder, allowing for the complexity of the mother's role, that images of the mother fall into such severe oppositions, for what the mother brings forth from her own body, she can also destroy. The concept of mother in matristic philosophy denoted a woman with the creative powers to give life through her blood, to love, to nurture, or to destroy progeny at will.

Her color is red: the color of blood, of sexuality, of life. Her moon is full and light-giving. Her season is the full summer which links the promise of the past spring with the inevitability of autumn and winter to come. Motherhood is a powerful and often shared position in matri-focused tribes. It is an awesome undertaking, one to be respected and feared.

Images of the mother suffer the same black/white, good/bad dichotomy that images of the virgin endure. Either she is all-sacrificing or all-suffering, as in the characters of Andromache, Penelope, Kwan Yin, Mary (as mother), Iocaste, Demeter, Coventry Patmore's angel of the house of late nineteenth century literature, Queen Victoria, Jewish mothers, and the non-existent mothers of fairy tale fame who always die before their virtuous daughters' stories begin. The mother's black side, the devouring or destructive mother, can be seen in such characters as Medea, Lilith, Arianrhod, Victoria (in Hellman's "Little Foxes"), Hera, Jewish mothers, and all the evil step-mothers of fairy tale fame.

As the patient, perfect mother, her sole purpose for living is to give her children life. She can keep the home fires burning in a perpetual endurance (Penelope) or she can inspire a nation to greatness simply by her presence (Queen Victoria). She can even challenge the heavens in safeguarding her children (Medea) or wantonly kills children belonging to others (Lilith). She can make or break a family's success (Victoria) or deny all claims to children born (Arianrhod).

These severe dichotomies point to the fragmentation of the mother image. Each of these fragments, when fitted together like the pieces of a puzzle, portray a greater, more complex picture that explains she is neither one nor the other but a composite of many images. Through the unification of these separate images, or through the realization that each separate image is a part of a greater whole, the image of the mother can undergo a humanizing process that celebrates her diversity through experience.

If the virgin phase of the goddess is potentiality, then the mother phase brings fruition to that potentiality. The mother lives in the realm of action and work; and her work is transformation. She decrees that which is possible and that which is impossible; she becomes the limits and guidelines, the yes's and no's, the rules and the laws that govern the individual as well as the collective. Her trials, through birth or transformation, establish her initiation into the human community. Her power comes from her experience in day to day life. Her creative impulses are not ends in themselves but beginnings for herself and others as she progresses through her own personal development: virgin to mother, mother to crone. Like Lachesis, she measures out our lives within the yonic circle of existence. Her endurance is our survival.

Notes

1. Ellen Goodman, "The Business of Surrogacy," in *Chicago Tribune*, 28 October 1990. See also Rita Ardith, Renate Duelli, and Shelley Minden, eds. *Test-Tube Women: What Future for Motherhood?* (Boston: Pandora Press, 1984) and Gena Corea, *The Mother Machine: Reproductive Technologies from Artificial Insemination to Artificial Wombs* (Harper & Row, 1985).

2. Nancy Chodorow, *The Reproduction of Mothering: Psychoanalysis and the Sociology of Gender* (Berkeley: University of California Press, 1979) 11.

3. Monica Sjöö and Barbara Mor, *The Great Cosmic Mother: Rediscovering the Religion of the Earth* (San Francisco: Harper & Row, 1987) 50.

4. Patricia Monaghan, *The Book of Goddesses and Heroines* (St. Paul: Llewellyn Press, 1990) 20, 117.

5. Marija Gimbutas, *The Language of the Goddess* (San Francisco: Harper & Row, 1989) 163-68.

6. Jamake Highwater, *Myth and Sexuality* (Markham, Ontario: Penguin Books Canada Limited, 1990) 44.

7. Diane Wolkstein, "Interpretations of Inanna's Stories and Hymns," in *Inanna: Queen of Heaven and Earth* by Diana Wolkstein and Samuel Noah Kramer (New York: Harper & Row, 1983) 144.

8. Sjöö 21.

9. Barbara G. Walker, *The Crone: Woman of Age, Wisdom, and Power* (San Francisco: Harper & Row, 1987) 115.

10. Evelyn Reed, "The Myth of Women's Inferiority," in *Problems of Women's Liberation* (New York: Merit, 1969) 22-41.

11. Adrienne Rich, *Of Woman Born: Motherhood as Experience and Institution* (New York: W. W. Norton, 1977) 88.

12. M. Esther Harding, *Women's Mysteries: Ancient and Modern* (Boston: Shambhala, 1990) 239.

13. Rich 89.

14. Rich 89.

15. Monaghan 206.

16. Sjöö 61-62.

17. Penelope Washbourn, *Becoming Woman: The Quest for Wholeness in Female Experience* (New York: Harper & Row, 1977) 170.

18. Sylvia Brinton Perera, *Descent to the Goddess: A Way of Initiation for Women* (Toronto: Inner City Books, 1981) 38.

19. Diana Wolkstein and Samuel Noah Kramer, *Inanna: Queen of Heaven and Earth* (New York: Harper & Row, 1983) 52.

20. Wolkstein, *Inanna* 53.

21. Wolkstein, *Inanna* 60.

22. Wolkstein, *Inanna* 64.

23. Perera 78.

24. M. Esther Harding, *The Way of All Women* (Boston: Shambhala, 1990) 172.

25. Harding, *The Way* 172.

26. Perera 7.

27. Perera 69.

28. Perera 72.

29. Perera 36.

30. Nor Hall, *The Moon and the Virgin: Reflections on the Archetypal Feminine* (New York: Harper & Row, 1979) 182.

31. Chodorow 82.

32. Shuli Barzilai, "Reading Snow White: The Mother's Story," in *Ties That Bind: Essays on Mothering and Patriarchy*, eds. Jean F. O'Barr, Deborah Pope, and Mary Wyer (Chicago: University of Chicago Press, 1990) 253.

33. Apostolos N. Athanassakis, *The Homeric Hymns* (Baltimore: Johns Hopkins Press, 1976) 5.

34. Chodorow 180.

35. Sara Ruddick, *Maternal Thinking: Toward A Politic of Peace* (New York: Ballentine Books, 1989) 131.

IV. The Crone's Return:

The Reconciliation of Female Heritage

Women, when they are old enough to have done with
the business of being women, and can let loose
their strength, must be the most powerful creatures
in the world.
Isak Dinesen

In modern society, the crone is perhaps the least valued member of
the Goddess trinity; as the virgin's value of youth is vastly overrated, the
crone in her age hardly exists at all, except for lonely streetcorners or
darkened, smelly rooms. Because youth, beauty, and procreative abilities
have been valorized by patriarchal societies, the crone has lost all sense
of worth and esteem. Yet, in matriarchal societies, the older a woman was,
the more she was valued and deified as the great matriarch of a clan or a
tribe. Her ability to recall experience and history became a hallmark for
her wisdom and worth to her society. There are some vestiges of this
concept that have survived in some cultures;

> Among American Indians and often in India and China also,
> the grandmothers are the recognized teachers. The older
> woman plays the part of the "Wise One" who imparts, not
> factual knowledge, but the wisdom of the race embodied in
> custom, dealing particularly with religious observance and
> with the relations of human beings.[1]

It is this sense of value that needs to be infused into the aspect of
the crone. It is her aspect that becomes the final phase of transformation
for woman's life. From virgin to mother, mother to crone, this passage
marks the accumulation of time, experience, and knowledge. In the hero's

journey, the crone marks the return to the top of the yonic circle, the reconnection to the value of female heritage, the fulfillment of the search, and the acceptance of self actualization. She has been one-in-herself; she has been a part of the social context; now, in her age, she can bestow wisdom, experience, and history to the generations who follow after her.

She is the winter of the year, the waning moon that promises to soon rise again after the darkness. Her color is the black of death, horrible to those who have not prepared themselves for their ultimate mortality. But for those who have accepted nature's inevitability, she is beautiful, promising the chance for rebirth, for renewal. She rises to the top of the yonic circle with the ability to see and understand the past and the future. Her words are oracles of wisdom and experience formed from the blood she now withholds in her body.

Menstruation ceases as menopause begins. The sacred blood of life that, by its flow, began the journey toward self actualization, that, by its cessation during pregnancy, became the coagulant material for a new human life, now ceases again, but this time to enrich the crone, to feed her the sacred life-affirming wisdom of her age, to ensure the perpetuation of the Goddess through her renewal and rebirthing back to the aspect of virgin. And so the cycle renews itself; and so life continues for another generation; and so the cyclic nature of the female life repeats another season. This is not to limit woman to nature; this is to free her to identify with the universe.

The crone emerges from the mother to again become one in herself. All of her responsibilities to her children are fulfilled, her active life in the social community slows. Time slows; instead, time is now marked by the peace of solitude, of meditation, of self again:

> No longer bound to their rhythms or their families, post-menopausal women are freed from any of the social or biological restrictions that patriarchy imposes on their lives... They are in the position to establish, perhaps for the first time in their lives, a separate identity.[2]

In the male hero myths, it is at this point that the hero, if he has survived his adventures wiser from his own heroic experiences, returns to

his people and shares the fruits of his wisdom, perhaps serving as a reminder of the more noble qualities of man. In that same spirit, the woman hero emerges from her maternal trials as woman made stronger through experience. If she has been patient and receptive to life, she returns the lessons learned to the young. If she values memory, she can restore a sense of history and continuity to her community. If she has spent her life marking time through the rhythms of her body, she now develops an eternal sense of timeless values. She feels her body's decay but accepts the wisdom that from death comes new life. She is reborn with every daughter.

The labels associated with the crone reflect the fruits of her labors. *Hag* means wisdom, *sibyl* means prophecy, *gossip* means divine words.[3] As mistress to the two worlds of time and eternity, she stands at the threshold between them, interpreting for those younger the lessons and values of human life and human mortality. She completes the cycle begun with the virgin. And, in her death, the crone becomes reborn to begin the cycle anew. Her reemergence fulfills the purpose for the virgin's descent and the mother's trials. The crone, transcending the virgin's self-aware-ness and the mother's adversities, moves into the realm of eternal values. From her vantage point, the crone stands as sovereign of the two worlds of time and eternity. As Joseph Campbell states in his analysis of the hero, the crone achieves the:

> Freedom to pass back and forth across the world division, from the perspective of the apparitions of time to that of the causal deep and back — not contaminating the principles of the one with those of the other, yet permitting the mind to know the one by virtue of the other....[4]

She accepts "life as perpetual transition";[5] she accepts the link of her own death with the potential of new growth, new life. A part of the original ancient worship of the goddess Hera celebrated her own renewal after the winter of her death; "Her worshippers bathed her image, renewing her youth and preparing her again for the seasonal cycle of maturation and death."[6] This "rejuvenating, revirginating bath"[7] effected the completion of the yonic circle of woman's heroic adventure. Instead of

the patriarchal timeline of linear development, the crone bends back toward the completion of a cycle, the yonic circle, that ensures the return of spring after the cold death of winter.

Her place in myth once echoed her transcendence: Hecate guards the entrance to the underworld as escort and interpreter to the passage from life into death, from time into eternity. She is Atropos, the Cutter of the thread of life, who completes the Greek trinity of Fates comprised of Clotho the Spinner, and Lachesis the Measurer, who comprise the virgin and the mother aspects. She is "Theira ('crone'), the woman who has passed through and beyond maternity and lives again to herself."[8] Other cultures as well parallel the crone's purpose and worth:

> The Chinese moon goddess, Shing Moo, is called Perfect Intelligence; Isis is Maat, the Ancient Wisdom; Ishtar sings "To give oracles do I appear, do I appear in Perfectness." In some of the Gnostic systems the Queen of Heaven is the Divine Sophia, the Wisdom.[9]

All of these personifications complete the monomyth of the heroic journey for women: the return of wisdom and life affirming energy to begin anew the cycle of life. Because of her experience and the knowledge gained, the crone becomes oracle, prophet, sibyl, for her people; she becomes one who sees beyond the limitations of the earthly into the realms of eternal values, truths, and inevitabilities.

Repository of Wisdom and Experience

Much Madness is divinest Sense.
Emily Dickinson

Useless in the procreative sense, the crone has very little worth in patriarchal social systems that value woman's reproductive abilities. That places the crone in the unique position of outsider in relation to a patristic society. And although she has historically been considered wise-

woman or herbal healer in many patristic cultures, her position has often been feared by men who had no control over her or her sisters:

> They were thus, in one way, a projection of men's fears, fears of energies which they did not control. Whereas virgins and matrons have been tied to patriarchal culture, and have given energy in some form to man, the witch, whether old depleted woman or simply woman who has reserved her powers for herself, has not been possessed by the patriarchy. Patriarchal men have always feared powerful woman.[10]

The fear of the crone, fear of her knowledge of medicine or midwifery, fear of her freedom, fear of the blood as essence of life held within her body, fear of her memory or of the prophecies she speaks have all led to persecutions for women living beyond their childbearing years. During and beyond the Middle Ages, the witchcraft hysteria of Western Europe destroyed countless numbers of women whose only crime was to outlive their husbands, cure disease, or deliver babies. Because the crone is the harbinger of memory and repository of years of accumulated knowledge and experience, her destruction during these centuries marked the near destruction of woman's culture and its replacement with patristic controls over medicine and religion. The destruction of the crone broke the yonic circle of return that marks the completion of woman's heroic journey back to herself, back to a female heritage.

That heritage implies a value for memory made rich through experience, a memory of myth and stories that codifies and enforces that experience with the lessons or knowledge of the process of womanhood, a womanhood that is not oppositional or divisive but one that empowers women with a heroic tradition that is their own. If we care to listen, the crone tells us the stories, riddles, or rhymes that teach the morals of her age.

> She is not the history-class memory that strings dates on a line with facts but the kind of re-membering or putting together again the body of our outward and inward journeyings. It is the kind of memory that calls up dreams, myths, and stories — the kind of memory that gives birth to the arts.[11]

That memory makes prophecy and oracles possible. The sibyl who sits upon the *omphalos*, the navel of the earth at the entrance to the womb-like underground cave, speaks in poetic oracular wisdom, guiding those like Psyche who commit to making the journey for themselves; the crone already has, and now she imparts her life experience to the next generation who follow her. Because the blood remains within the body of the crone, she retains mystical powers of enlightenment denied to the inexperienced young. Her life becomes their model, or their warning.

As the repository of wisdom and experience, the crone also dispenses laws that govern the relationships between people. She keeps the social and family history of a culture alive and pertinent to those who follow after her. In matristic cultures, the older she became, the more reverenced she was; and after her death, she was worshipped as the matriarch of the people, finally to emerge as the Goddess herself to the generations reborn in her heroic daughters and granddaughters, source and endpoint to her sons' and grandsons', the male heroes', adventures.

The crone's affirmation of life can be seen through her connection with midwifery, a skill handed down through generations of women. This connection to birth exemplifies the yonic circle's connection to ongoing life. Unfortunately, it is also this skill which helped fuel the fires of witch burnings as more men became certified university doctors in the Middle Ages.[12] By burning out this connection to natural birthing procedures, centuries of herbal arts were almost completely wiped out within a few generations.[13]

In the Demeter myth, while she is waiting for some word about the whereabouts of her daughter Persephone, Demeter disguises herself as an old woman as she "sits on the edge of the Maiden Well to await the uprising of her daughter self from the depths";[14] she goes to work for a family in need of a nurse for their young son. While in their employ, Demeter takes the baby boy and begins a process toward making him immortal by "anointing him with ambrosia"[15] and passing his little body through the sacred flames of her hearth. When the mother discovers what Demeter is doing, she cries out in protest, breaking Demeter's spell. It is at this point that Demeter reveals herself to the worried mother as the

Great Goddess:

> ...the goddess changed her size and form
> and sloughed off old age, as beauty wafted about her.
> From her fragrant veils a lovely smell
> emanated, and from the immortal skin of the goddess a light
> shone afar, as her blond hair streamed down over her
> shoulders,
> and the sturdy mansion was filled with radiance as if from
> lightning.[16]

In this part of the myth, Demeter has become nursemaid to another woman's baby. And even though she cannot care for her own daughter, she tries to impart the ambrosia, her life-sustaining wisdom, to the next generation. When she reveals herself to the anxious mother, she takes on the transformative aspect of the crone, the mistress of life and death. She reconnects with youth by demonstrating the power of the crone to influence the life and death processes of human beings through her own eternal nature.

In fairy tales, the crone almost always appears as guide, teacher, or mentor to the young virgin hero; this mentor is necessary to the hero for the guidance and wisdom of one who has already passed this way before. Even Inanna through the god Enki, or more accurately, the goddess Ninhursaga, has her guide into and out of the underworld of Ereshkigal. Psyche has her guide in Aphrodite, who both helps and hinders Psyche's progress. Hecate hears Persephone's cries as she descends into the underworld, and tells Demeter where her daughter might be found. Cinderella has her fairy godmother, and even Dorothy from *The Wizard of Oz* has Glinda the Good Witch. These characters, fictional and mythological, complete the yonic circle connection between the older generation and the younger; "and we may take it also, I should think, that the considerable mutual attraction of the very young and the very old may derive something from their common, secret knowledge that it is they, and not the busy generation between, who are concerned with a poetic play that is eternal and truly wise."[17] The crones impart their wisdom and experience, as well as their ability to see beyond the constraints of youth and work, to help the hero proceed and ultimately complete her journeyings.

Mistress of Death and Life

Time and trouble will tame an advanced young woman,
but an advanced old woman is uncontrollable
by any earthly force.
Dorothy L. Sayers

The crossroads, gateways, and passages ruled by the crone are hallmarks of her sovereignty over transformation as well as complements to the mother's symbols of caves and labyrinths. Her connections to the virgin hero complete the circuity of woman's heroic journey. This is represented in the third day of the Thesmophoric festivals which were concluded with the last phase, the *Kalligeneia* or Fair-Born or Fair-Birth, indicating the completion of the cycle by the rebirth of the Goddess; "in the first human religious rites, rebirth-resurrection-reincarnation were believed to occur within the body of the Mother, as birth, death, and rebirth occur in the great cycles of nature."[18] The Thesmophoric festivals parallel the story of Demeter and Persephone, at the end of which Hecate, the crone and guardian of the crossroads, becomes Persephone's constant "attendant and follower,"[19] at the same time completing and rebeginning the circuity of woman's journey.

This sense of transformation allows the passage from death (crone) to birth (virgin); without this transformation, death ceases to have purpose for the natural world: "The real meaning of the [Eleusian] Mysteries was this reintegration of death and birth."[20] The butterfly has its chrysalis from which it will emerge in its reborn glory: from the tomb of the crone back to the womb of the virgin. There is a sense of a transformation of energy never really lost, only remade, re-membered into new life, thus completing and beginning again a cycle of life from the experience of death. Ancient peoples were so convinced of this transformation of energy that they buried their dead in a fetal position, painted with red ocher to symbolize the reanimating properties of the blood of the

womb. In the myths of woman's self actualization, this transformation or rebirth is symbolized by the death and resurrection of the female hero. Again we turn to the myth of Inanna for illustration.

After Inanna's death in the realm of Ereshkigal and her reanimation into life, "Inanna arose"[21] to ascend once again to her own realm. She is informed, however, that to leave she must provide someone to take her place. Accompanied by the "*galla*, the demons of the underworld,"[22] she ascends to find a suitable substitute. But she rejects the choices of the *galla* who ask for Ninshubur her servant, and Shara and Lulal her sons, all of whom have mourned the loss of Inanna. When Inanna finally arrives back at Uruk, back to the location of the "big apple tree"[23] that marked her initial celebration of her vulva when she was a virgin and the place she and her lover Dumuzi had first made love, she and the *galla* discover Dumuzi dressed magnificently in the glorious robes of "shining *me*-garments"[24] that once adorned Inanna. He has not been mourning; he has not been depressed over the loss of Inanna, but instead he has taken her place on her throne.

> The *galla* seize him...
> Inanna fastened on Dumuzi the eye of death.
> She spoke against him the word of wrath.
> She uttered against him the cry of guilt:
> "*Take him! Take Dumuzi away!*"[25]

which the *galla* attempt to do, but Dumuzi escapes and calls for his sister, Geshtinanna, to hide him. A chase ensues throughout the cities of Sumer; each time the *galla* close in on Dumuzi, he gets away. Finally, he runs to the house of Old Belili and asks the crone for her help in hiding him from the *galla*. The old woman allows him in and pours water for Dumuzi before leaving her house. When the *galla* see her leave, they rush in and almost catch Dumuzi, but he escapes again and runs to the sheepfold of his sister Geshtinanna. Here, the *galla* finally capture and subdue him. They cry:

> "Rise, Dumuzi!
> Husband of Inanna, son of Sirtur, brother of Geshtinanna!
> Rise from your false sleep!...
> Take off your holy crown from your head!
> Take off your *me*-garment from your body!

Let your royal scepter fall to the ground!
Take off your holy sandals from your feet!
Naked, you go with us!"
The *galla* seized Dumuzi...
The churn was silent. No milk was poured.
The cup was shattered. Dumuzi was no more.[26]

Several motifs come into play at this point in the story. First, Inanna arises from the realm of Ereshkigal with the power over death; once the mistress of life, she has now acquired the full potentiality of her being: mistress of life and death. She chooses Dumuzi for her substitute in death because even though she had made him king, he had no compassion or sympathy for the trials she had just faced. Instead, he had made himself more important than she, denying Inanna even a small amount of compassion.

Secondly, the story provides the justification for the sacrifice of the king in place of the Great Goddess, an integral part of the rituals of many ancient peoples. This sacrifice at the end of winter ensures new growth for the spring that would follow. Sacrifice humanizes people, "for through suffering Dumuzi awakens fully to the reverence of fear and to his mortality."[27] Dumuzi "returns to the sheepfold or 'womb' [which] is the Great Earth Mother, who gives birth and takes back the dead."[28] Dumuzi must undergo the ritual abandonment of his realm, city by city, that Inanna had to undergo in giving up each part of her queenly regalia, piece by piece;

Inanna's curse topples Dumuzi from his fixed position and forces him to face the dark, demanding aspects of his wife, as well as the uncontrollable, inexplicable, irrational mystery of life and death and the kingdom of Ereshkigal... Dumuzi, too, in fleeing from Uruk to Kubiresh to Old Belili, prepares himself to leave the earth for his own journey of transformation.[29]

Finally, the myth codifies Inanna's queenship and her ability to transcend the boundaries between death and life. Once Dumuzi is taken, his sister Geshtinnana begs her to have mercy on her brother. Inanna is moved by Geshtinanna's grief and together they go to find Dumuzi. A "holy fly"[30] appears and tells the two women where Dumuzi can be found.

Because of Geshtinanna's compassion for her brother, Inanna decrees that brother and sister will alternate half years in the underworld, half years on earth. She then places Dumuzi "in the hands of the eternal."[31]

It is obvious that Inanna's name is embodied within that of Geshtinanna; the connection between Ereshkigal and Inanna has already been established as mirror-images of each other. Patricia Monaghan writes that in some versions of the myth, "Inanna herself was sometimes said to be Dumuzi's mother."[32] Taken together, these three representations of Inanna represent the constantly changing face of the Great Goddess and the concept of the Goddess's interrelatedness with all women, as well as her divine trinity. Inanna's connection between time and the eternal, and her connection between life and death, become her hallmark as crone. Wisdom gained from her own life and death experience give her the ability to judge and to sympathize. This fragment of myth concludes with praises sung to Ereshkigal, Inanna's own mirror-image, and her mystical powers of transformation.

The descent and return that is decreed for Dumuzi and Geshtinanna parallel the descent and return of Persephone from the realm of the underworld. Both sets of mythical characters are ultimately caught in the cycle of death and rebirth which signifies the vegetative growth of Mother Nature. Both descend and return while the Great Goddess herself (Inanna, Demeter) decrees change. Both sets of mythical characters become part of a new world order; because of their adventures, the seasons of the year alternate between the life-giving spring and summer of their return which are balanced by the death-bringing autumn and winter of their descents. Both die and are reborn because of the transformative powers of the crone.

Inanna's "eye of death"[33] is the evil eye of ageless superstitions; it is the same evil eye attributed to Lilith, the same evil eye condemned and feared in medieval witchcraft as well as myth; "so Athena, *gorgopsis* (bright-eyed) and owl-eyed, wore the Gorgon's eyes on her shield."[34] So, too, "the All-Seeing Eye of ancient Egypt once belonged to the Goddess of Truth and Judgment, Maat," as well as to the Mesopotamian Goddess Mari and the Indian Kali.[35] The eye itself symbolizes the power to see beyond the obvious, to detect the hidden, to observe across the boundaries

of time. It is this power that belongs to the crone as oracle, prophet, and judge.

The crone's completion of the yonic circle is also symbolized by her controlling influence over the mythological cauldron. The Celts, Indians, Babylonians, Japanese, Egyptians, Persians, and Greeks all refer to the symbol of the cauldron,[36] as does the Grail of medieval quests and the "vas hermeticum"[37] container used in alchemy; "The name of Cerridwen has been translated both as Cauldron of Wisdom and Fortress of Wisdom."[38] In all cases, the crone's control over the cauldron containing the blood and wisdom of the Goddess represents the ability to create or destroy life; it is a veritable "cauldron of collected energy"[39] that transforms matter and inspires poets: "'Inspiration' may be the breathing-in by the poet of intoxicating fumes from an intoxicating cauldron"[40] with the Goddess herself as source.

Fairy Godmothers vs. Wicked Witches: Dichotomy of Self

The old woman I shall become will be quite different from the woman I am now. Another I is beginning, and so far I have not had to complain about her.
George Sand

Having gleefully chased butterflies in our young days on our way to school, we thought it might be as well to chase them in our old age on the way to heaven.
Elizabeth Cady Stanton

The dichotomy of female imagery continues into the last phase of a woman's life as well. The crone has been shown in the same extreme terms as her younger counterparts. The positive, guiding force who

connects back with the young virgin can be seen in the forms of Hecuba, Naomi (from the Book of Ruth), Saint Ann, the Nurse (from "Romeo and Juliet"), Rhea, Gaia, and the fairy godmothers from the fairy tales. The negative, evil old hag of death has been personified as Medusa, the Furies, any old gypsy woman, Hecate, Night-Mare, Queen of the Shades, MacBeth's witches, Madame Sosostris (in T.S. Eliot's "The Wasteland"), and last but certainly not least, the Wicked Witch of the West.

In some fairy tales, both the positive and the negative crones appear and battle each other for possession of the virgin; for example, Sleeping Beauty or *The Wizard of Oz*. In myth, the negative crone is usually destroyed by the young male hero, as with Perseus and Medusa, Apollo and Python, Herakles and Hydra. In slaying the crone, the male hero usually acquires her powers of magic, prophecy, or potency. It is from her destruction or death that new orders arise.

As in all of the dichotomies outlined in any of the Goddess' phases, the crone represents neither one nor the other, but is a composite of many aspects. Her personifications of either death or life represent the continuity of human life essential to the ongoing propagation of the species:

> The goddess mother of the alternating tides of life and death, who formerly had been chiefly of this earth, became then equally of the cosmic order in its ever- circling rounds of day and night, creation and dissolution; and under innumerable names — as Inanna, Isis, Hathor and Nut, Anahit, Sati, Mary, and Kwan Yin — she receives worship as the supreme personification of that ambiguous mystery, *tremendum et fascinans*, which is of life in death, as of death in life.[41]

Another major symbol illustrating the crone's connection between life and death is the double-edged axe, the labrys, which is related to the labyrinth, a symbol of the Goddess' womb and the rebirth into a higher realm of consciousness. The labrys itself cuts both ways: the umbilical cord of birth as well as the cutter's tool for death. In terms of the labyrinth, which becomes the adventure map for the journey of the hero,

> it was necessary to find the way to the center and then to make a full 360-degree turn, to turn completely around on oneself to go out the way one came in.... it was the temple

sweeper Labys who is credited with the maxim "Know thyself." Temple attendant, labyrinth, and the double-edged axe are entwined.[42]

This kind of power, this awesome responsibility, belongs to the crone. To silence her, or worse, to negate her function completely cuts women off from their own cycle of rebirth, from passing on women's knowledge and traditions to the next generation, from enriching the present and the future with the experience of the past. The rediscovery and re-valuation of the crone, however, gives a sense of continuity to woman's experience, as well as providing — not only an end — but a rebirth toward a new beginning for woman as hero.

Notes

1. M. Esther Harding, *The Way of All Women* (Boston: Shambhala, 1990) 251.

2. Janice Delaney, Mary Lupton and Emily Toth, *The Curse: A Cultural History of Menstruation* (Urbana: University of Illinois, 1988) 223.

3. Barbara G. Walker, *The Crone: Woman of Age, Wisdom, and Power* (San Francisco: Harper & Row, 1987) 53. Also, Barbara G. Walker, *The Women's Encyclopedia of Myths and Secrets* (New York: Harper & Row, 1983) 350 and Nor Hall, *The Moon and the Virgin: Reflections on the Archetypal Feminine* (New York: Harper & Row, 1980) 189.

4. Joseph Campbell, *The Hero With A Thousand Faces* (Princeton: Princeton University Press, 1978) 229.

5. Walker 33.

6. Patricia Monaghan, *The Book of Goddesses and Heroines* (St. Paul: Llewellyn Press, 1990) 153.

7. Sylvia Brinton Perera, *Descent to the Goddess: A Way of Initiation for Women* (Toronto: Inner City Books, 1981) 55.

8. Monaghan 153.

9. M. Esther Harding, *Women's Mysteries: Ancient and Modern* (Boston: Shambhala, 1990) 225.

10. Miriam Robbins Dexter, *Whence the Goddess: A Source Book* (New York: Pergamon Press, 1990) 182.

11. Hall 27.

12. Monica Sjöö and Barbara Mor, *The Great Cosmic Mother: Rediscovering the Religion of the Earth* (San Francisco: Harper & Row, 1987) 204.

13. Mary Daly, *Pure Lust: Elemental Feminist Philosophy* (Boston: Beacon Press, 1984) 222.

14. Hall 206.

15. Apostolos Athanassakis, *The Homeric Hymns* (Baltimore: Johns Hopkins Press, 1976) 8.

16. Athanassakis 9.

17. Joseph Campbell, *The Masks of God: Primitive Mythology* (New York: Penguin Books, 1987) 123.

18. Sjöö 79.

19. Athanassakis 14.

20. Adrienne Rich, *Of Woman Born: Motherhood as Experience and Institution* (New York: W. W. Norton, 1977) 242.

21. Diane Wolkstein and Samuel Noah Kramer, *Inanna: Queen of Heaven and Earth* (New York: Harper & Row, 1983) 67.

22. Wolkstein 68.

23. Wolkstein 71.

24. Wolkstein 71.

25. Wolkstein 71.

26. Wolkstein 83-84.

27. Perera 85.

28. Diane Wolkstein, "Interpretations of Inanna's Stories and Hymns," in *Inanna: Queen of Heaven and Earth* by Diane Wolkstein and Samuel Noah Kramer (New York: Harper & Row, 1983) 165.

29.Wolkstein, "Interpretations" 163.

30. Wolkstein, *Inanna* 88.

31. Wolkstein, *Inanna* 89.

32. Monaghan 169.

33. Wolkstein , *Inanna* 71.

34. Perera 34.

35. Barbara G. Walker, *The Women's Encyclopedia of Myths and Se-crets* (New York: Harper & Row, 1983) 294.

36. Walker, *Crone* 104.

37. Walker, *Encyclopedia* 19.

38. Merlin Stone, *Ancient Mirrors of Womanhood* (Boston: Beacon Press, 1979) 58.

39. Hall 167.

40. Robert Graves, *The White Goddess* (New York: Farrar, Straus and Giroux, 1966) 439.

41. Joseph Campbell, *Historical Atlas of World Mythology: The Way of the Animal Powers*, vol. 1 (New York: Harper & Row, 1988) 49.

42. Hall 9-10.

V. Epilogue:
The Female Myth in Society

All the institutions of our culture tell us through words,
deeds, and even worse, silence,
that we are insignificant.
But our heritage is our power.
Judy Chicago

dream the myth on...
C.G. Jung

Over the course of her life, woman's journey of self actualization presents a pattern of development from virgin to mother, and mother to crone, reflecting that "her biological phases are also spiritual phases"[1] of growth, change, and transformation exemplified by the progression of female archetypal images. For myth, literature, and popular culture, these collective images of woman dramatize an heroic adventure of the female monomyth that allows and acknowledges woman as hero of her own story.

If it is the male hero's quest to search out and reconnect with the feminine — the land, the earth, woman herself — then can we not assume that the male hero motif was at some point overlaid to her preexisting myth, so old and so basic that it became the backdrop for the male monomyth. We enter a landscape; on that landscape, a tiny knight in shining armor races across back and forth, slashing at the air with his tiny sword while the landscape, its colors moving and pulsing with life, changes so slowly and gradually, we can barely mark its progress. As it changes, the little knight grows older and even smaller until he disap-

pears completely from sight, but the landscape always remains constant, even in its changes. If this is so, then the male hero's journey is an imitation of the greater journey he was once a part of, a journey he emulates: woman's journey.

Not surprisingly, therefore, the markers for the woman hero's journey are buried within the male hero's myth. Once the overlay is stripped, however, we come face-to-face with the Great Goddess: virgin, mother, crone. Brought to the foreground are the passages each woman faces in the course of her life, from her spring of possibility, to her summer of lush fruition, to her winter of promise. As virgin, she acknowledges her potential as she accepts the power of choice and decision-making. She garners strength from her one-in-herself status and learns how to maintain her integrity within the scope of personal relationships. As mother, she undertakes the responsibility inherent in her choices as she creates and sustains life, confronting her own internal dialogue between desire and self-denial, between self and created, between individual and society. Finally, as crone, she retrieves her life lessons in an accumulation of wisdom that fulfills a transcendent consciousness linking her to her past heritage and a future more promising. She moves through these phases with an accelerating sense of personal power to make what becomes a seamless whole of experience, an evolution of being toward the goal of individuation. She finds her strength in the myths that codify her internal experience as woman; her life imitates the stories told of her mythological heroes:

> [An] essential function of mythologies, then, is the pedagogi-
> cal one of conducting individuals in harmony through the
> passages of human life, from the stage of dependency in
> childhood to the responsibilities of maturity, and on to old
> age and the ultimate passage of the dark gate.[2]

To see woman as hero of her own adventure is to see her as a principled human being, aware of her moral and ethical decisions and responsibilities. She is, after all, the mother of the gods, whether she is Mawu of northwest Africa or Hera of ancient Greece, Estsan-Natlehi (She-Who-Changeth) of the Navajos or Mary of Christianity.

To place woman as hero does not displace man. To value woman's journey toward self actualization does not devalue male heroic adventures. To see woman as the matristic ancients must have — mystical, magical, divine — is not to see man as purely and all-too-human. Instead, a fuller portrait of woman should only add to our knowledge and appreciation of the experience of being human.

The Dis-Function of Fragmented Images

The woman I needed to call my mother was silenced before I was born.
Adrienne Rich

It isn't difficult to find evidence of patriarchal misogyny in the fragmented images of the female archetype: society's emphasis on female youth and beauty, its basic devaluation of motherhood, its inability to accept woman as a moral being, its abandonment of the elderly, its negation of age. But woman's history, woman's culture, and woman's experience tell of something different, something more than the isolated portrait of an ancient goddess. The power that goddess images invokes points to a reality undervalued and feared in patristic societies; "and no matter how hard patriarchy tries to suppress our past matriarchal history, it keeps 'bobbing to the surface' — in worldwide archeological ruins, icons, and myths, as in our dreams."[3]

By allowing the many fragments of the Great Goddess to remain as individual pieces linked to patristic systems as wives, lovers, or whores, women will remain separated from each other. But to recognize the individual pieces as belonging to a greater whole allows for the purpose of continuum throughout a woman's life and throughout a woman's community. Valued as pieces in an eternal state of arrested development diminishes woman to the point of procreative tool, but valuing the whole of a woman's life is to see her as a positive contributor to the continuity of life: a hero with a sense of moral responsibility and personal autonomy.

A Call For Reunification of the Female Archetype

...there is, at this time, no general woman, no typical woman. What they have in common *I will say.*
Helene Cixous

Now that all of these fragments have been identified, a movement toward their reunification must take place to order these fragments into a complete portrait of the female archetype. No one phase — be it virgin, mother, or crone — can adequately describe — or should define — the whole of a woman's life. Any one person can claim the rite of passage inherent with life's growth and change. That same rite of passage must allow for the unification of the archetypal female as a progression of development for the self. Giving back the memory of that developing consciousness through myth can influence the critical interpretations of the traditional canons of literature and myth.

The evidence of the existence of divine female trinities marks the circuity of experience that unites virgin, mother, crone in a female monomyth expanding a woman's life into a yonic circle of change and transformation. The structure of her journey consists of "passing over fields of the feminine to find places of archetypal convergence"[4] which allows for woman's presence and purpose to be expanded in myth. It also allows for reuniting the three phases of the Goddess into a full portrait of woman's life: Hera as Antheia, Nympheuomene, and Theira; the Arabian Al-Uzza, Al-Lat, and Manat; the Celtic Brigid, Brigit, and Bridget; the Scandinavian Freya, Frigg, and Fyorgyn; the Mexican Coatlique as Coyolxauhqui, Tonantzin, and Tlaltecuhtli, the Indian Devi as Maya, Shakti, and Prakriti; the Chinese Kuan-Yin as Yu Nu, Sheng-Mu, and T'ien Hsien; the Polynesian Hina-Titama, Hina, and Great Hina; the Lithuanian Ausrine, Zleja, and Breksta; the Greek Persephone, Demeter,

and Hecate; the Irish Morrigan of Macha, Badb, and Nemain; the Greek Fates of Clotho, Lachesis, and Atropos; or of Tethys, Nyx, and Gaia.

Her colors are white, red, and black, symbolizing consciousness, energy, and darkness.[5] Her constancy in change is represented by the moon in all of its phases, the earth in all changes of season, and the turning of the sky around the unchanging pole-star. Her yonic circle of experience moves from creation to transformation to recurrence.

The Thesmophoric festival of ancient Greece is one of the few remnants of ritual that explains how these trinities of virgin, mother, crone were woven into a tapestry of woman's existence and purpose. The participating women passed through each phase of the divine trinity within the three-day festival to experience passage, growth, and change as the divine markers for woman's heroic journey.

Even Inanna's story demonstrates the passages of woman's heroic journey in coming to full terms of the meaning of her existence. Her departure, initiation, and return define the female heroic monomyth, allowing Inanna to exemplify the trinity of experience rather than remain as an artifact of a distant past:

> Our planet is passing through a phase — the return of the goddess — presaged at the beginning of patriarchy in this myth. Its emphasis then was on the descent of the goddess, the loss to culture of her energies and symbols, and the subsequent retrieval of the powers symbolized in Ereshkigal. Our age can appreciate the full *circulatio*, for more and more of the feminine was repressed, and it has been too long in the underworld.[6]

The Inanna story is one of the few remnants of myth that demonstrates the circuitous pattern of woman's development. Her story provides the universal pattern of the female monomyth spanning the biological, psychological, seasonal, and mythological components of woman's life. Her story is our story: the Thesmophoric festival is our celebration.

An Acceptance of the Journey:
The Old/New Female Myth

> While we may debate the specifics from one point of view or
> another, two things seem unequivocal: (1) We have consis-
> tently undervalued attachment in developmental patterns,
> and (2) these findings have radical implications for challeng-
> ing some of the dominent epistemologies of our culture. The
> existence of these two different contexts for ethical judgment
> may also imply different developmental tasks for men and
> women at various life-stages.[7]

The female monomyth that I am suggesting empowers each indi-
vidual woman with the ability to see herself as hero of her own adventure
story. To understand what the ancients already knew — that woman's life
is the heroic journey of self actualization — empowers woman with a
universal compassion for her sisters while celebrating her world-wide
diversity. A female monomyth is hardly a reductionism of the concept of
woman; instead, it becomes a unifying force of identification "that is
shared by great numbers of women across time, space, and human
culture."[8] The female monomyth moves woman from the background of
the male hero's adventure into the foreground of her own journey of
change and transformation. The Great Goddess becomes less an ancient
artifact and more a recognition that the source of the adventure is within
the development and actualization of the self.

The Great Goddess, just as woman herself, cannot be reduced to one
face, one skin color, or one age. She is infinite in her variety, but she is
always woman. She is personified by all the diverse elements of the
universe. In the beginning, she is Nut or Tanith the sky, Gaia or Hertha
the earth, Ri or Diana the moon, Sunna or Grian the sun, Sedna the sea,
Tu-Njami or Poza-Mama the fire, Tou-Mou or Lemkechen the pole-star,
Gendenwitha the morning star, Aurora the dawn, Hemera the day, Nyx
the night, Horae the seasons of time, Aetna, Chuginadak, Fuji, Darago, or
Pele the volcano, Rauni the thunder, Guabancex or Shina-To-Be the wind,
Sulis the healing waters, Syrinx the marsh, Sif the autumn grass, Aze the
pine tree, Daphne the laurel, Saosis the acacia, O-Ryu the willow, Clytie

the sunflower, Philomel the sparrow, Procne the swallow, Psyche the butterfly, Melissa the bee, Demeter the corn, Henwen the sow, Artio the bear, Rhiannon, Hippo, or Epona the horse, Io, Sibilja, Suki, or Surabhi the cow, Rhea Silvia the wolf, Aida-Wedo the snake, and Arachne the spider.

Taken together, her personifications comprise the universe in its magnificent variety; her separate faces are beautiful, but they do not exist alone; she is a complex eco-system of interrelated life forms, always changing, always coming into life, into production, and passing into death, leaving behind the promise of new life. Even scientists, coining the term the *Gaia complex* to describe the earth's life systems, recognize her diversities, her strengths, and her delicate balances that must be maintained for her to continue to exist.

For women to have a future in modern society, they must first have a past that can take them from the margins of time and place them in the center of human experience — not as fragments, not as dichotomies of polar opposites — but as the unified presence of the archetypal female personified in the "attributes of the Great Goddess as the projections of women's experience of themselves."[9]

The journey is the purpose; the fragments are all the little pieces of the dismembered Goddess who once made the journey. She is not content to be merely the source of life for the male hero nor even his reason for making his journey. She has her own journey of consciousness, being, and transcendence which allows her her own adventure journey; "she is not the being-of-the-end (the goal), but she is how-far-being-reaches."[10] Her existence implies the whole of woman's experience, an adventure of self actualization beyond biology, beyond the limited conscriptions of patristic society, into an expansion of woman's role in society:

> When I say "woman," I'm speaking of woman in her inevitable struggle against conventional man; and of a universal woman subject who must bring women to their senses and to their meaning in history.[11]

And just as the images of male gods can illustrate male passages from infancy to old age, the images of female deities can also be linked

together to form an unbroken chain of female development. The retrieval of myths that illustrate this full development can allow a woman to reclaim the personal power inherent in the quest for individuation. As hero, she holds up half of the sky as full partner to her husband, brother, or friend. Her story is her own.

The place of the hero in myth and literature is a place of the self, an adventure of individuation that leads to an actualization of purpose and dimension. And that place carries with it its own sense of "happily ever after."

Notes

1. Monica Sjöö and Barbara Mor, *The Great Cosmic Mother: Rediscovering the Religion of the Earth* (San Francisco: Harper & Row, 1987) 97.

2. Joseph Campbell, *Historical Atlas of World Mythology: The Way of Animal Powers,* vol. 1 (New York: Harper & Row, 1988) 9.

3. Sjöö 32.

4. Nor Hall, *The Moon and the Virgin: Reflections on the Archetypal Feminine* (New York: Harper & Row, 1980) 33.

5. Barbara G. Walker, *The Crone: Woman of Age, Wisdom, and Power* (San Francisco: Harper & Row, 1987) 79.

6. Sylvia Brinton Perera, *Descent to the Goddess: A Way of Initiation for Women* (Toronto: Inner City Books, 1981) 15.

7. Madonna Kolbenschlag, *Kiss Sleeping Beauty Good-Bye* (San Francisco: Harper & Row, 1979) 219.

8. Estella Lauter and Carol Schreier Rupprecht, *Feminist Archetypal Theory: Interdisciplinary Re-Visions of Jungian Thought* (Knoxville: University of Tennessee Press, 1985) 14.

9. Sjöö 500.

10. Helene Cixous and Catherine Clement, *The Newly Born Woman,* trans. by Betsy Wing (Minneapolis: University of Minnesota Press, 1975) 87.

11. Cixous 245.

Bibliography

Athanassakis, Apostolos N. *The Homeric Hymns*. Baltimore: Johns
 Hopkins University Press, 1976.
Bachofen, J. J. *Myth, Religion, and Mother Right: Selected Writings of
 J. J. Bachofen*. trans. by Ralph Manheim. Princeton: Princeton
 University Press, 1973.
Briffault, Robert. *The Mothers*. Abridged, with an introduction by
 Gordon Rattray Taylor. New York: Atheneum, 1977.
Cameron, Averil and Amelie Kuhrt, eds. *Images of Women in
 Antiquity*. Detroit: Wayne State University Press, 1983.
Campbell, Joseph. *The Hero With A Thousand Faces*. Princeton:
 Princeton University Press, 1968.
——. *Historical Atlas of World Mythology*. New York: Harper &
 Row, 1988.
——. *The Masks of God: Occidental Mythology*. New York: Penguin
 Books, 1964.
——. *The Masks of God: Oriental Mythology*. Princeton: Princeton
 University Press, 1968.
——. *The Masks of God: Primitive Mythology*. Princeton:
 Princeton University Press, 1968.
Cixous, Helene and Catherine Clement. *The Newly Born Woman*.
 trans. by Betsy Wing. Minneapolis: University of Minnesota
 Press, 1975.
Chodorow, Nancy. *The Reproduction of Mothering: Psychoanalysis
 and the Society of Gender*. Berkeley: University of
 California Press, 1979.
Daly, Mary. *Beyond God the Father: Toward a Philosophy of Women's
 Liberation*. Boston: Beacon Press, 1977.

——. *Gyn-Ecology: The Metaethics of Radical Feminism.* Boston: Beacon Press, 1978.

——. *Pure Lust: Elemental Feminist Philosophy.* Boston: Beacon Press, 1984.

Delaney, Janice, Mary Lupton, and Emily Toth. *The Curse: A Cultural History of Menstruation.* Urbana: University of Illinois Press, 1988.

Dexter, Miriam Robbins. *Whence the Goddess: A Source Book.* New York: Pergamon Press, 1990.

Eisler, Riane. *The Chalice and the Blade: Our History, Our Future.* San Francisco: Harper & Row, 1987.

Farrar, Janet and Stewart. *The Witches' Goddess.* Custer: Phoenix Publishing, 1987.

Frazer, Sir James George. *The Golden Bough: A Study of Magic and Religion.* New York: Macmillan, 1963.

French, Marilyn. *Beyond Power: On Women, Men, and Morals.* New York: Summit Books, 1985.

Gadon, Elinor W. *The Once and Future Goddess: A Symbol for Our Time.* San Francisco: Harper & Row, 1989.

Gimbutas, Marija. *The Goddesses and Gods of Old Europe: Myths and Cult Images.* Berkeley: University of California Press, 1982.

——. *The Language of the Goddess.* San Francisco: Harper & Row, 1989.

Goldenberg, Naomi. *Changing of the Gods.* Boston: Beacon Press, 1979.

Goodrich, Norma Lorre. *Priestesses.* New York: HarperCollins, 1989.

Graves, Robert. *The Greek Myths.* vol. 1&2. New York: Penguin Books, 1984.

——. *The White Goddess: A Historical Grammar of Poetic Myth.* New York: Farrar, Straus and Giroux, 1966.

Hadas, Moses, ed. *Greek Drama.* New York: Bantam, 1965.

Hall, Nor. *The Moon and the Virgin: Reflections on the Archetypal Feminine.* New York: Harper & Row, 1980.

Harding, M. Esther. *The Way of All Women.* Boston: Shambhala, 1990.

——. *Women's Mysteries: Ancient and Modern*. Boston: Shambhala, 1990.

Heilbrun, Carolyn. *Hamlet's Mother and Other Women*. New York: Columbia University Press, 1990.

Highwater, Jamake. *Myth and Sexuality*. Markham, Ontario: Penguin Books Canada Limited, 1990.

Johnson, Buffie. *Lady of the Beasts: Ancient Images of the Goddess and Her Sacred Animals*. San Francisco: Harper & Row, 1988.

Jung, Carl G. *The Archetypes and the Collective Unconscious*. trans. by R.F.C. Hull. Princeton : Princeton University Press, 1959.

——. *Man and His Symbols*. New York: Doubleday, 1964.

Keuls, Eva C. *The Reign of the Phallus: Sexual Politics in Ancient Athens*. New York: Harper & Row, 1985.

Kolbenshlag, Madonna. *Kiss Sleeping Beauty Good-Bye*. San Francisco: Harper & Row, 1979.

Kramer, Samuel Noah, ed. *Mythologies of the Ancient World*. New York: Doubleday, 1961.

Lauter, Estella and Carol Schreier Rupprecht, eds. *Feminist Archetypal Theory: Interdisciplinary Re-Visions of Jungian Thought*. Knoxville: University of Tennessee Press, 1985.

Lerner, Gerda. *The Creation of Patriarchy*. New York: Oxford University Press, 1986.

Monaghan, Patricia. *The Book of Goddesses and Heroines*. St. Paul: Llewellyn Press, 1990.

Neumann, Erich. *The Great Mother: An Analysis of the Archetype*. trans. by Ralph Manheim. Princeton: Princeton University Press, 1963.

O'Barr, Jean F., Deborah Pope and Mary Wyer, eds. *Ties That Bind: Essays on Mothering and Patriarchy*. Chicago: University of Chicago Press, 1990.

Olson, Carl, ed. *The Book of the Goddess: Past and Present*. New York: Crossroad, 1989.

Perera, Sylvia Brinton. *Descent to the Goddess: A Way of Initiation for Women*. Toronto: Inner City Books, 1981.

Plaskow, Judith and Carol P. Christ, eds. *Weaving the Visions: New Patterns in Feminist Spirituality*. San Francisco: Harper & Row, 1989.

Pomeroy, Sarah B. *Goddesses, Whores, Wives, and Slaves: Women in Classical Antiquity*. New York: Schocken Books, 1975.

Pratt, Annis P. *Archetypal Patterns in Women's Fiction*. Bloomington: Indiana University Press, 1981.

Reed, Evelyn, "The Myth of Women's Inferiority." in *Problems of Women's Liberation*. New York: Merit, 1969.

Rich, Adrienne. *Of Woman Born: Motherhood as Experience and Institution*. New York: W.W. Norton, 1977.

Ruddick, Sara. *Maternal Thinking: Toward a Politic of Peace*. New York: Ballentine Books, 1989.

Sjöö, Monica and Barbara Mor. *The Great Cosmic Mother: Rediscovering the Religion of the Earth*. San Francisco: Harper & Row, 1987.

Stone, Merlin. *When God Was A Woman*. New York: Harcourt, Brace &Jovanovich, 1976.

Trask, Haunani-Kay. *Eros and Power: The Promise of Feminist Theory*. Philadelphia: University of Pennsylvania Press, 1986.

Walker, Barbara G. *The Crone: Woman of Age, Wisdom, and Power*. San Francisco: Harper & Row, 1987.

——. *The Women's Dictionary of Symbols and Sacred Objects*. San Francisco: Harper & Row, 1988.

——. *The Women's Encyclopedia of Myths and Secrets*. New York: Harper & Row, 1983.

Washbourn, Penelope. *Becoming Woman: The Quest for Wholeness in Female Experience*. New York: Harper & Row, 1977.

Wehr, Demaris S. *Jung & Feminism: Liberating Archetypes*. Boston: Beacon Press, 1987.

Wolkstein, Diana and Samuel Kramer. *Inanna: Queen of Heaven and Earth*. New York: Harper & Row, 1983.

Index

patriarchy, patristic, 4, 6, 13, 25,
31, 34, 37, 43, 48, 50, 58, 64, 83
Pele, 37
Penelope, 59, 60
Perera, Sylvia Brinton, 52
Persephone, 3, 11, 17f, 25, 26f, 32,
57, 69, 71
Perseus, 76
Phaedra, 36
Philomel, 36
pomegranate, 18, 27, 30
pregnancy, 43f, 47, 51
Princess Leia, 36
Psyche, 32f, 36, 38, 69, 70
Pythia, 37
Python, 76

Queen of the Shades, 76
Queen of Sheba, 15
Queen Victoria, 59, 60

Ra, 15
Rapunzel, 36
rebirth, 9, 30, 38, 45, 46, 65, 74,
76
Red Riding Hood, 25, 36
Reed, Evelyn, 49
Rhea, 76
Rich, Adrienne, 49

sacrifice, 9, 55, 56, 73
Scathach, 37
Sekhmet, 37
Selene, 36

self actualization, 3, 38, 57, 65,
72, 87
Shin Mu, 36, 67
Shiva, 15
sibyl, 66, 69
Sirens, 36
Sleeping Beauty, 27, 32, 36, 76
Snow White, 32, 36, 56
Sophia, 8, 67
Spretnak, Charlene, 30
Stone, Merlin, 7, 22
Sumerian, 10, 15, 27, 29, 51

Tammuz (and Ishtar), 33, 37
Tao, 8
Tauret, 54
Theira, 67, 84
Thesmophoric Festival, 18, 24, 54,
55, 71, 85
Tiamat, 12, 47
Tinkerbell, 36
Tomyris, 54
trinity, 46, 64, 67, 85

Uke-Mochi, 37
Uma, 37
Utset, 37

vas hermeticum, 75
Vechernyaya, 37
virgin, 6, 19, 22-23, 45, 65, 66, 81,
82
virgin birth, 9, 22